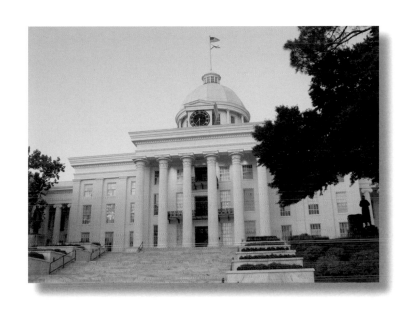

ALABAMA

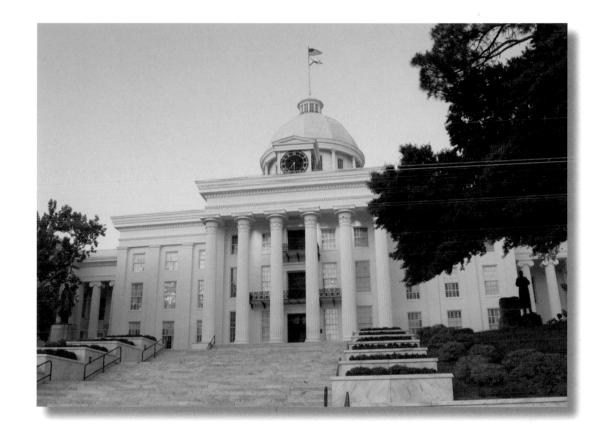

whitecap

Written by Claire Leila Philipson
Edited by Ben D'Andrea
Photo editing, cover, and interior layout by Claire Leila Philipson

Printed and bound in Canada

Library and Archives Canada Cataloguing in Publication

Philipson, Claire Leila, 1980-

 Alabama / Claire Leila Philipson.

ISBN 978-1-55285-908-7
ISBN 1-55285-908-8

 1. Alabama--Pictorial works. 2. Alabama--History. I. Title.
F324.3.P48 2007 976.1'0640222 C2007-901778-9

The publisher acknowledges the financial support of the Government of Canada through
the Book Publishing Industry Development Program (BPIDP) and the Province of British
Columbia through the Book Publishing Tax Credit.

For more information on the America Series and other titles from
Whitecap Books, please visit our website at www.whitecap.ca.

From colonization and the short-lived Confederacy to industrialization and the civil rights movement, Alabama's tumultuous past has unfolded against an incredibly varied geography — from the rugged mountains in the north and the marshy bayous of the Mobile River Delta to the sand dunes of the Gulf Coast and lively cities.

Long before Europeans discovered Alabama, Indian nations — including the Chickasaw, Cherokee, Creek, and Choctaw tribes — inhabited the land. The Choctaw in particular have made a lasting contribution: some of the earliest European settlers merged the Choctaw words *alba*, roughly translating to vegetation, and *amo*, meaning gatherer, to name the Alabama River and subsequently the state.

European colonizers have also had a major influence in shaping Alabama. The French brothers Pierre Le Moyne d'Iberville and Jean-Baptiste Le Moyne de Bienville arrived in the area at the turn of the 17th century and founded the La Mobile settlement, now the city of Mobile. The brothers not only established a colony but also introduced the region to one of its biggest celebrations — Mardi Gras.

Over a century later in 1819, Alabama became the 22nd state to join the union and then in 1861 the fourth to secede and form its own republic. A month after claiming independence, the fleeting Confederate States of America was founded in Alabama. The Confederacy's only leader, Jefferson Davis, took the oath of office on the steps of the Alabama State Capitol in Montgomery. The Confederacy crumbled in 1865 and Alabama was readmitted to the union in 1868.

The 20th century brought the civil rights movement, during which Alabama became the backdrop for the struggle for equality for African Americans. It was here that Martin Luther King Jr. led the infamous Selma to Montgomery marches, which are credited with leading to the Voting Rights Act of 1965 that finally granted suffrage to African Americans.

Seven different flags have flown over Alabama's soil — Spain, France, Great Britain, the U.S.A., the Republic of Alabama, the Confederate States of America, and the State of Alabama — and each culture represented by those flags has helped to shape the remarkable history that has unfolded on this breathtaking landscape.

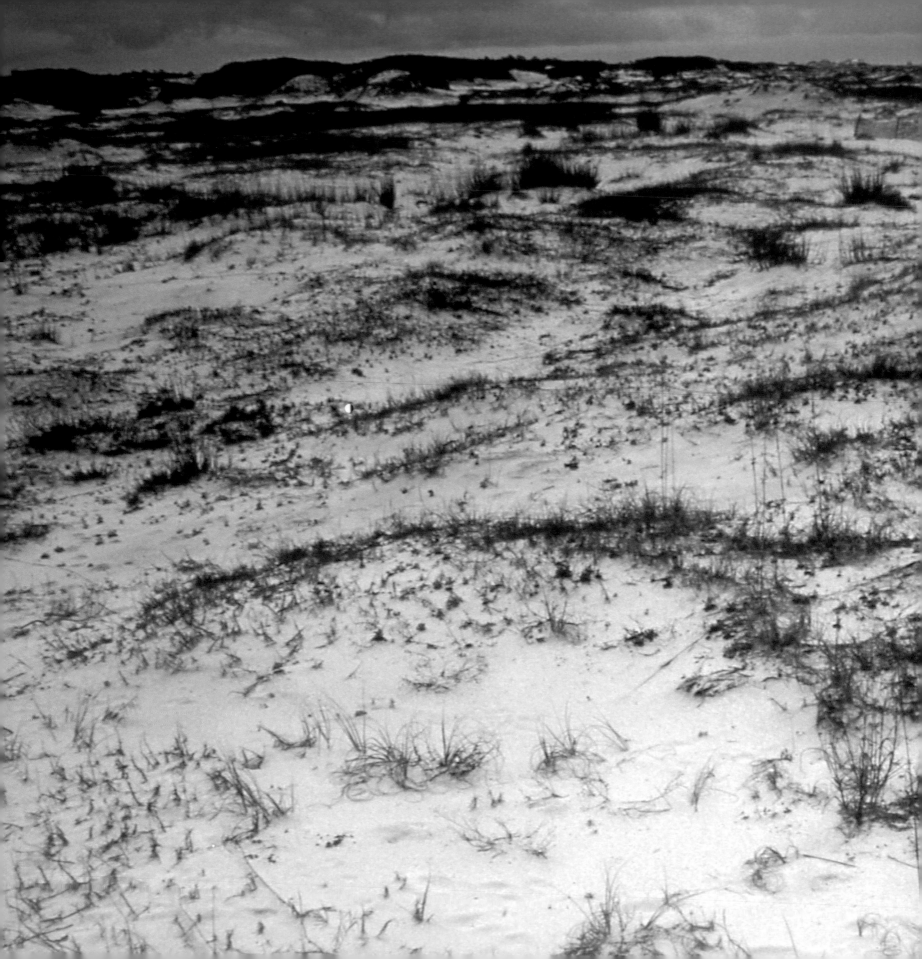

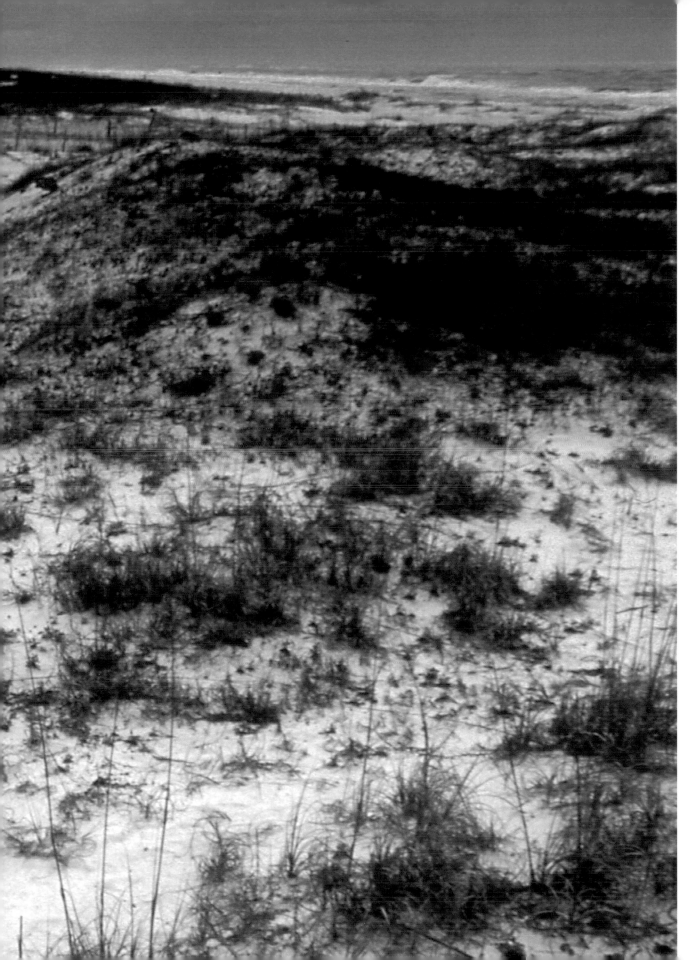

Providing a glimpse of the undeveloped natural beauty that used to characterize the Gulf Coast, the sand dunes of the Bon Secour Wildlife Refuge on the Fort Morgan Peninsula are considered one of Alabama's greatest natural wonders. These sand dunes are home to the endangered Alabama beach mouse, whose tail accounts for over half its body length.

Taking its name from the French words for safe harbor, the Bon Secour Wildlife Refuge consists of over 6,800 acres of preserved animal and bird habitat. Established in 1980, the refuge provides important habitat for the endangered Alabama beach mouse, nesting sites for sea turtles, and a migratory stopover for numerous types of birds. Other species that depend on the refuge include alligators, coyotes, and armadillos.

Hundreds of vessels transporting tons of goods pass through the Alabama State Port every year. Since its completion in 1927, the port's docks at Mobile Bay on the Gulf of Mexico have managed mammoth ships delivering imports like aluminum, iron, and steel, and transported Alabama's exports like soybeans, coal, and lumber. One of the largest ports in the nation, it has a billion-dollar impact on Alabama's economy.

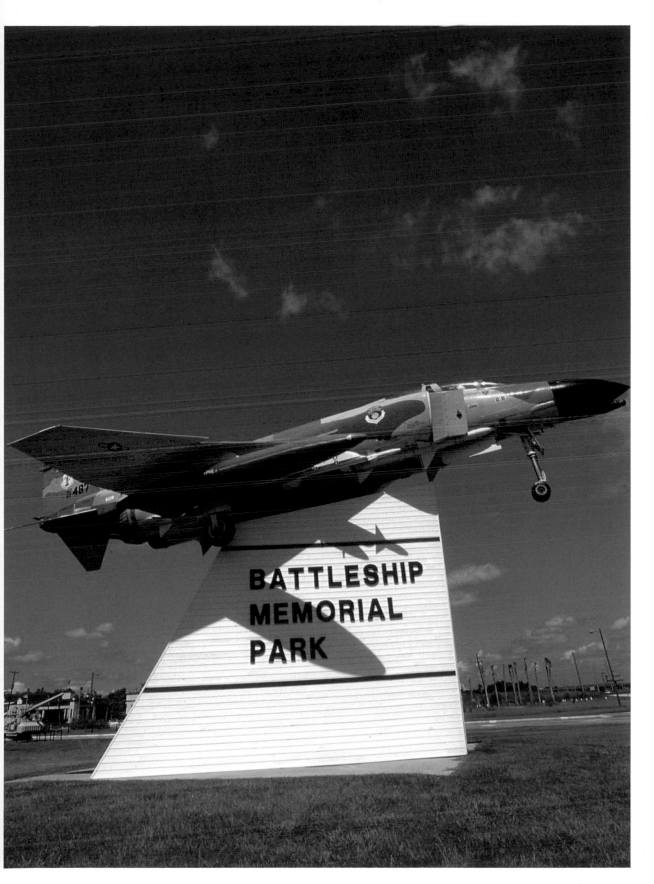

One of the most extensive military parks in America, the Battleship Memorial Park in Mobile chronicles over seven decades of military activity from World War II to Desert Storm through artillery, aircraft, and ships. In addition to the authentic equipment, the park also features memorials to the Korean and Vietnam wars.

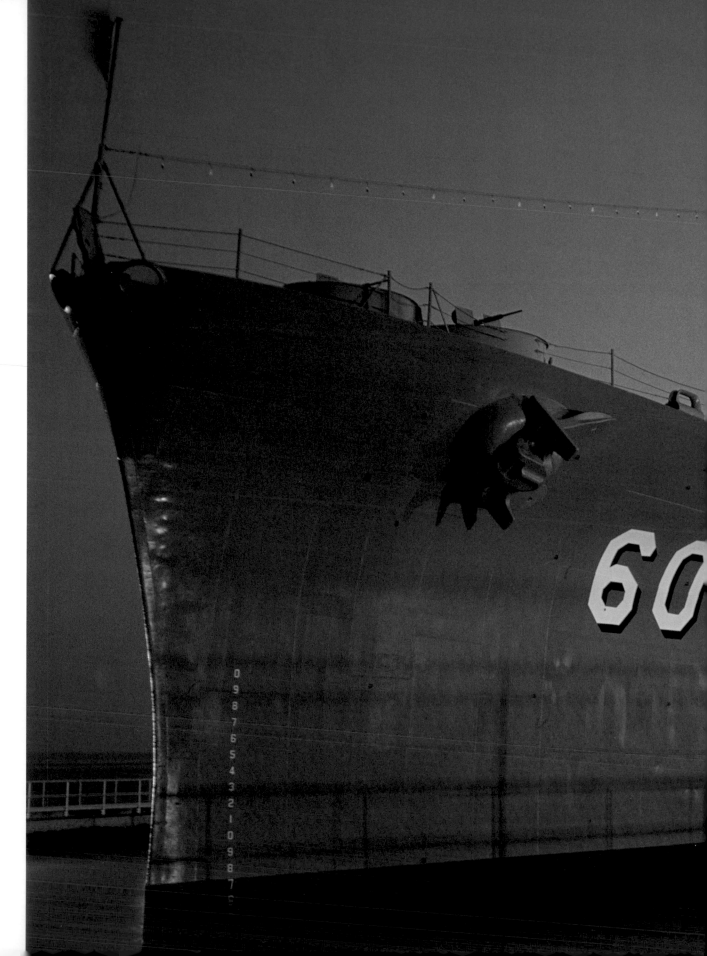

The sixth U.S. Naval ship to bear the name USS *Alabama*, this South Dakota Class battleship was launched in 1942. Serving in the Pacific during World War II, this mammoth vessel won nine battle stars from 1943–1945, earning her the nickname the Mighty A. Now the centerpiece at the Battleship Memorial Park, the USS *Alabama* is dedicated to Alabamian veterans of the United States Armed Services.

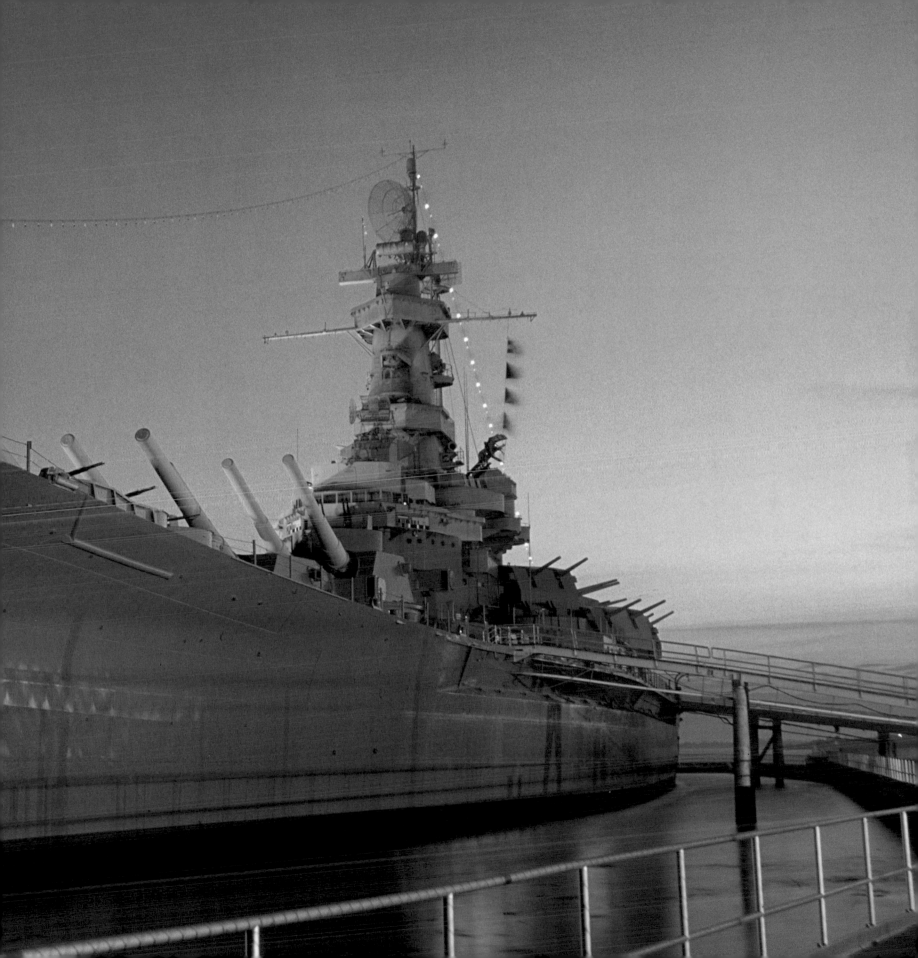

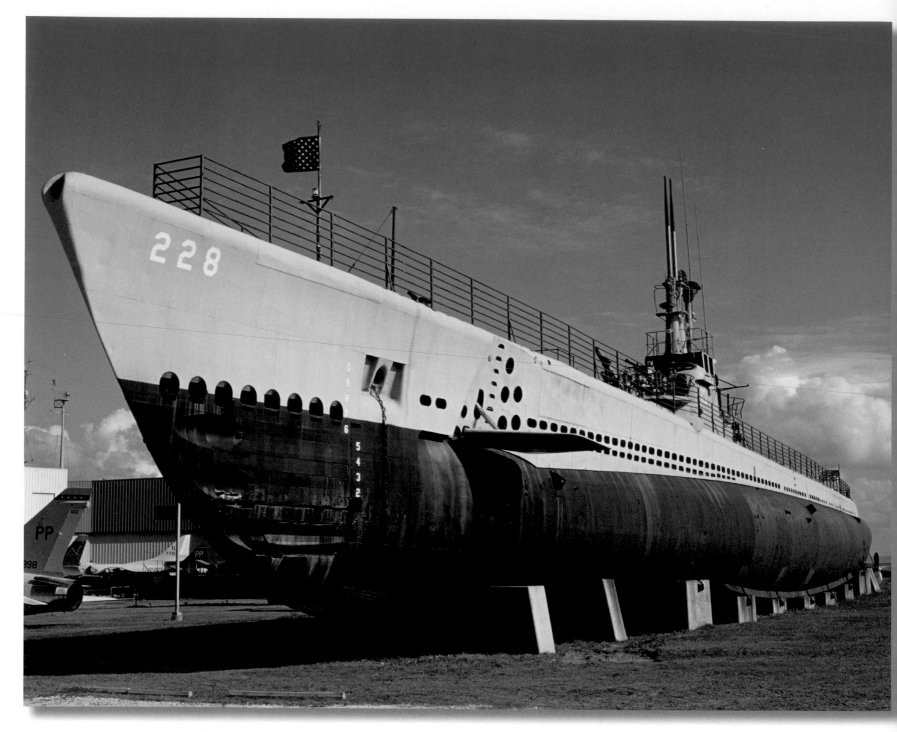

During her active tour of service, the USS *Drum*, more than 300 feet long, patrolled the Pacific, sinking numerous Japanese ships during World War II. Commissioned in 1941, this mammoth submarine could once dive to depths of 400 feet. The USS *Drum* was towed to Mobile, Alabama, in the spring of 1969 and opened to the public as a museum on July 4, 1969.

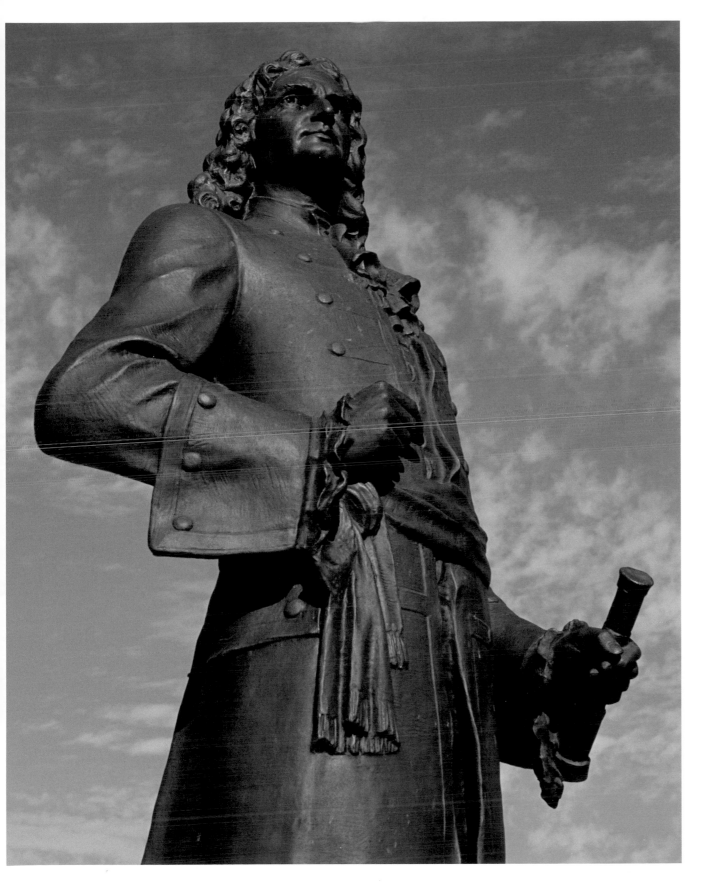

The founder of the
Louisiana and La
Mobile colonies,
the settlements that
later became Mobile,
Alabama, Pierre
D'Iberville presides
over Riverside Park.
The man sent by
French King Louis
XIV to defend
France's claims in the
new world is honored
with this 9-foot-tall,
1,500-pound bronze
statue, dedicated
in 2002 as part of
Mobile's tercentennial
celebrations.

The Carnival Museum in Mobile, Alabama, traces the history of Mardi Gras, one of the most raucous, and colorful celebrations in the world. The day before Ash Wednesday and the beginning of Lent, Mardi Gras, or Fat Tuesday, is marked with parades, floats, and costumes. Brothers Pierre d'Iberville and Jean-Baptiste de Bienville brought the celebration to America when King Louis XIV of France sent them to the Southern U.S. states to defend French territory. Mobile is the site of the first American Mardi Gras celebrations in the early 18th century.

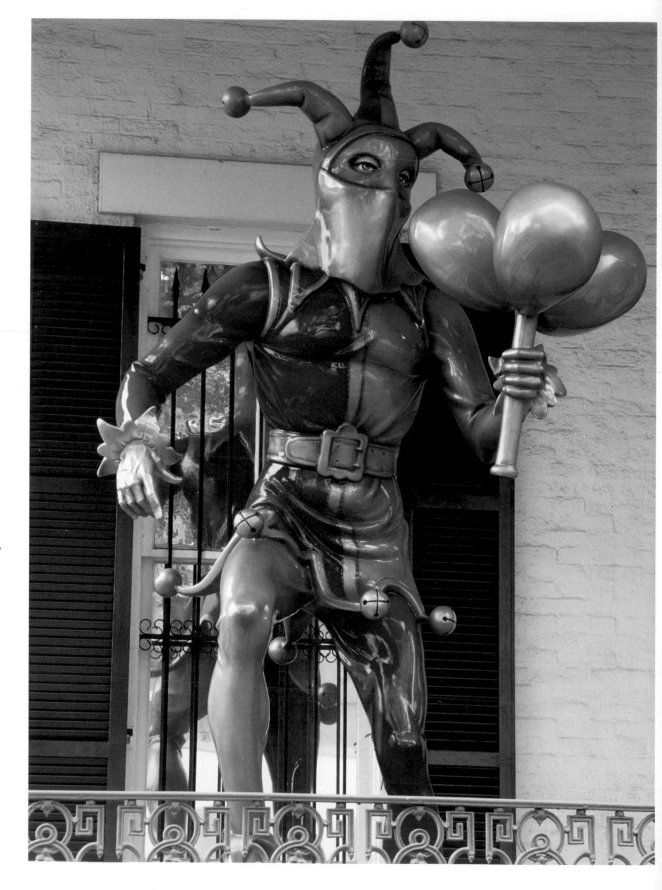

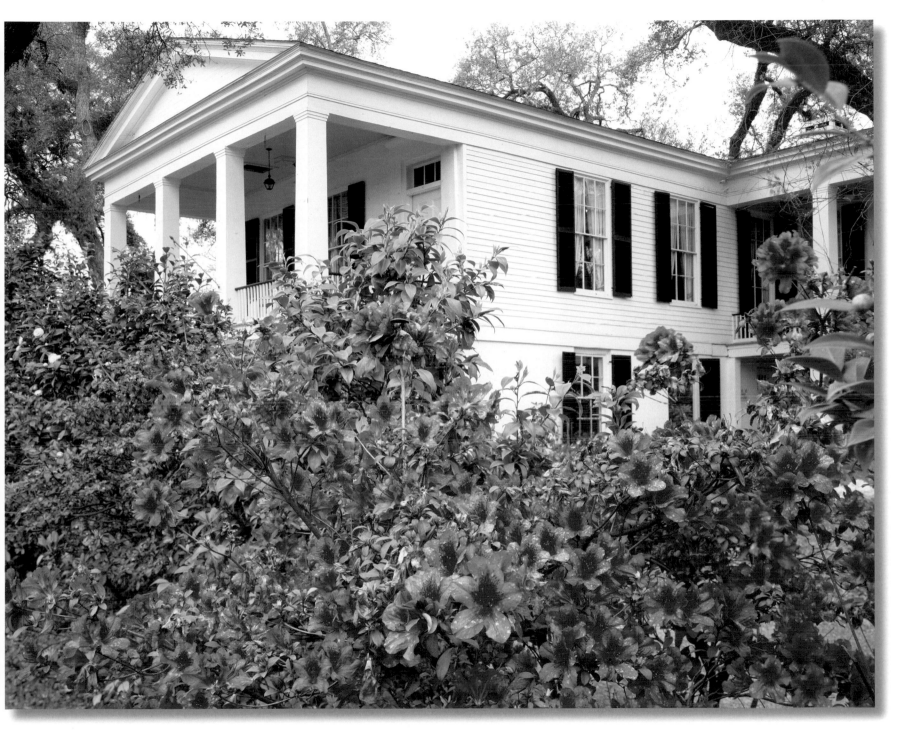

Once the home of Virginian entrepreneur James W. Roper, Oakleigh is now Mobile's official Period House Museum and Historic Complex. Designed by Roper, the Greek revival mansion features opulent parlors, galleries, and a cantilevered staircase. Listed on the National Register of Historic Places, the Oakleigh Period House Museum and Historic Complex recreates daily life in the 19th century.

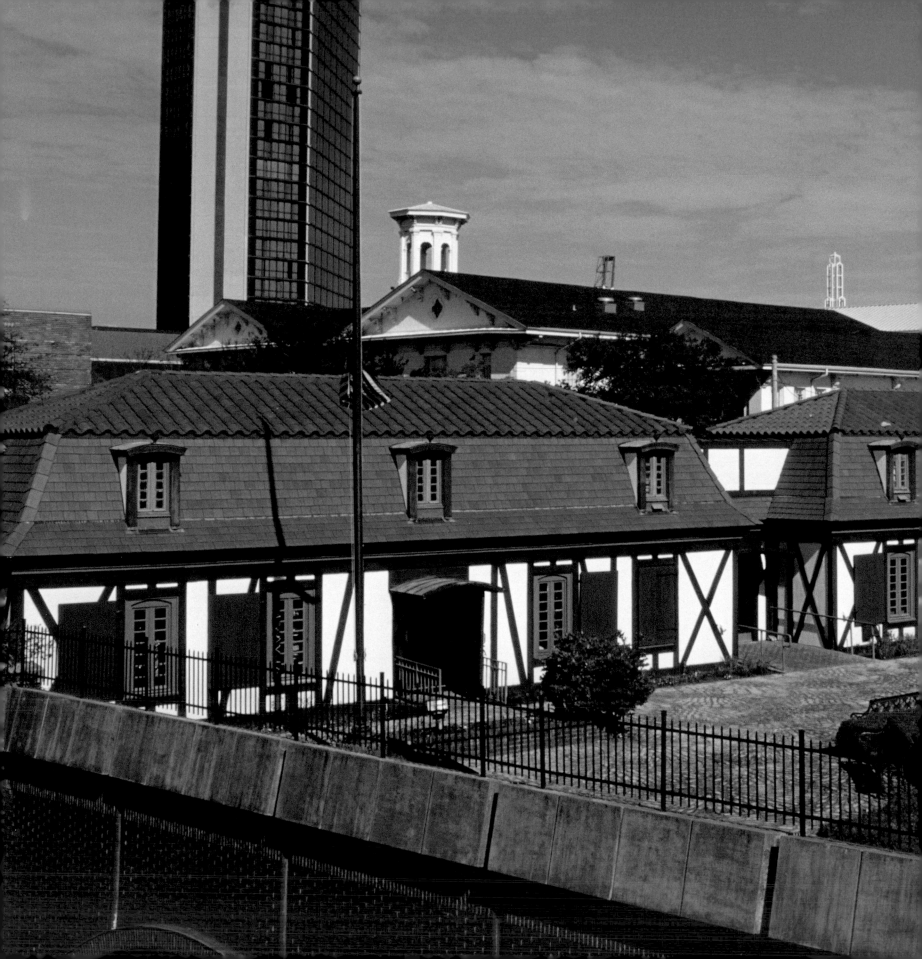

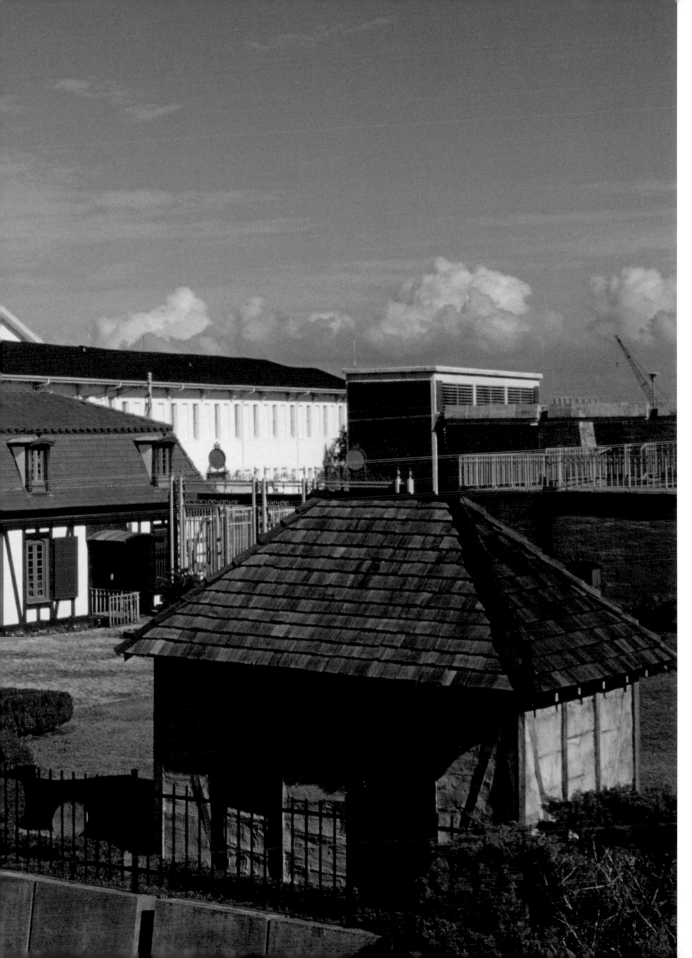

A strategic military stronghold in the south, the city of Mobile used to be surrounded by Fort Condé. Named in honor of King Louis XIV's brother, the fort was built by the French to protect the town from Spanish and British attacks. As Mobile passed from the French to the Spanish to the British and finally to the Americans, the fort — recreated at one third of its original size at the Museum of Mobile — protected its citizens.

Different aspects of 18th-century life are recreated at Fort Condé, from the kinds of houses people lived in and the places where they shopped to the cannons they fired. The original Fort Condé was built with wood in 1702 and then relocated in 1711 when the town of Mobile was moved downriver. Construction of Mobile's new fort began in 1723, this time with brick, stone, dirt, and cedar.

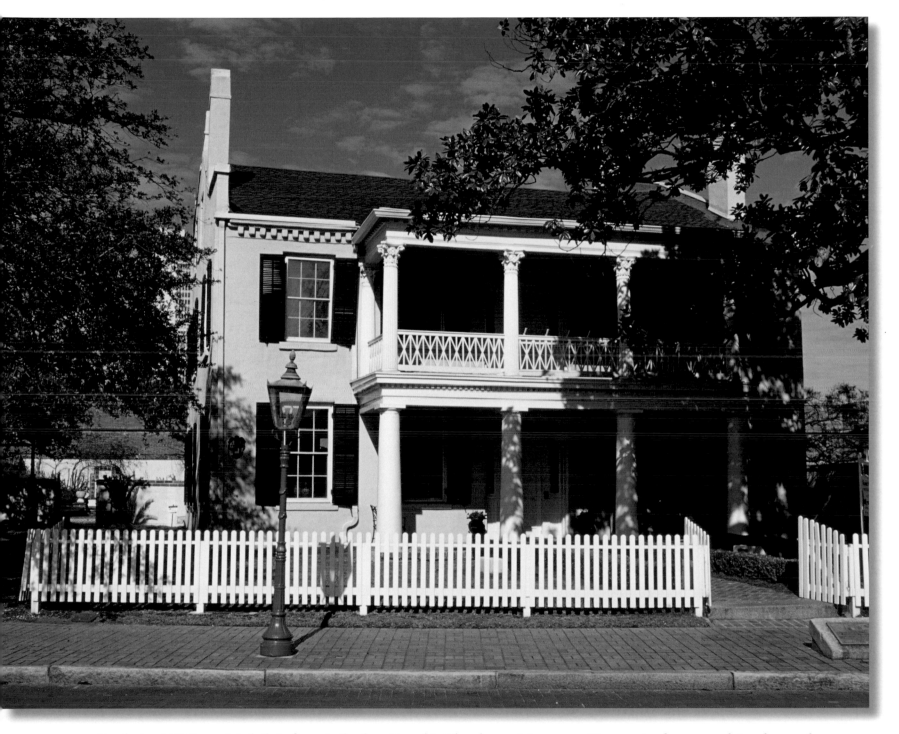

Built in 1822 as Mobile's first jail, the Condé-Charlotte Museum House is decorated in the style of five eras and four nationalities — French empire, 18th-century English, 18th-century Spanish, American Federal, and American Civil War. Owned by the National Society of Colonial Dames in America, the museum features the original cannons from the French Fort Condé and Fort Charlotte.

Spanish Plaza in downtown Mobile honors the city's roots as a colony of Spain from 1780 – 1813, and its sister city of Malaga, Spain. The tree-lined plaza features numerous artistic gifts from its Spanish sister, including this aptly named sculpture *Arches of Friendship*. Other gifts from Malaga include the statue of a fishmonger, the fountain, and a plaque for Malaga-born Louisiana Governor Bernardo de Galvez.

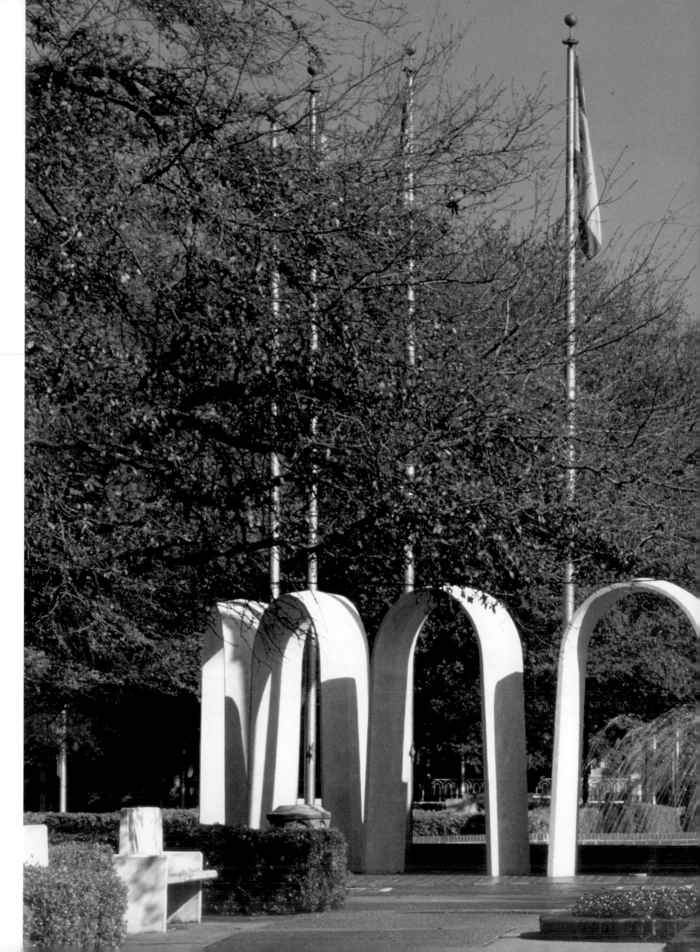

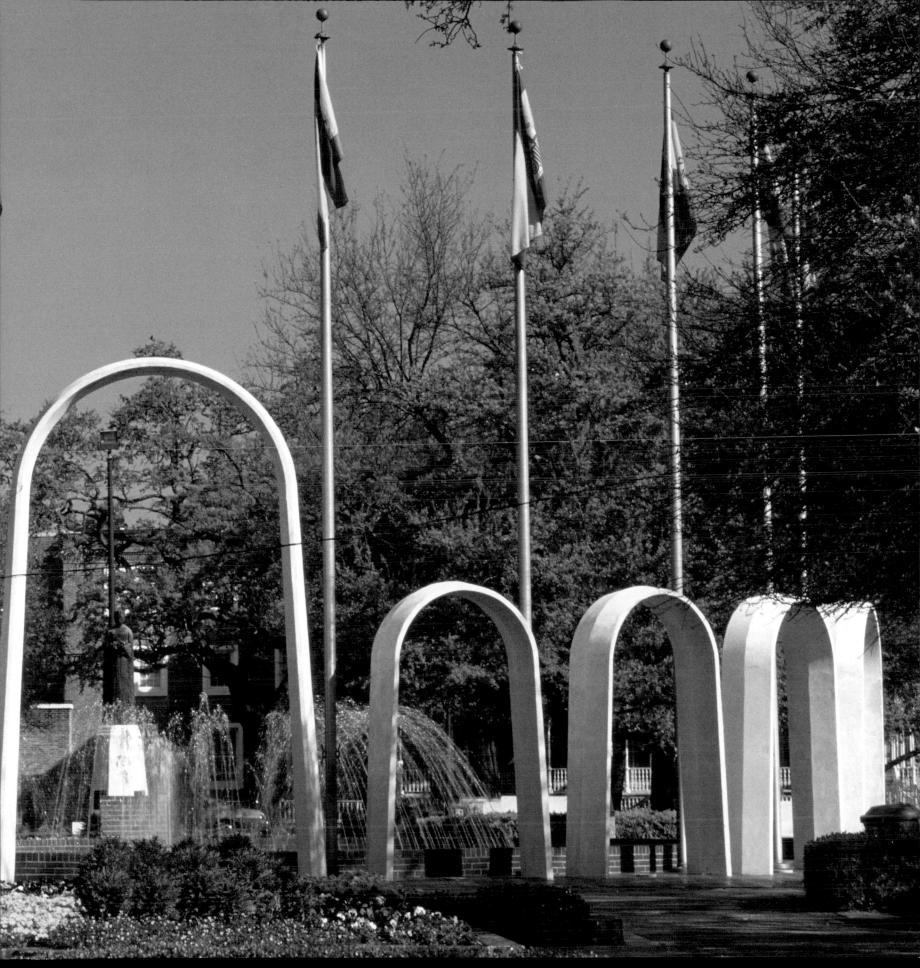

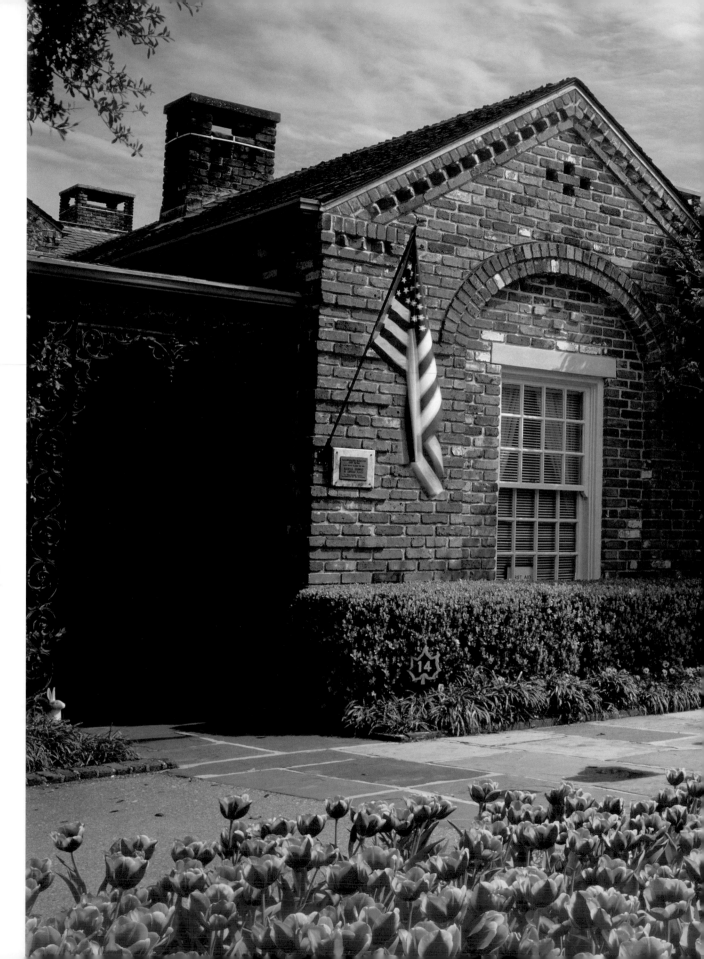

The 65-acre estate at Bellingrath Mansion is a meticulously manicured array of bright blossoms and greenery. The gardens of this early 20th-century English renaissance home have been open to the public since 1932, when Mr. and Mrs. Bellingrath put an ad in the local paper inviting the residents of Mobile to view them. Furnished with the Bellingrath's original fixtures and art collection, the house is now also open to the public.

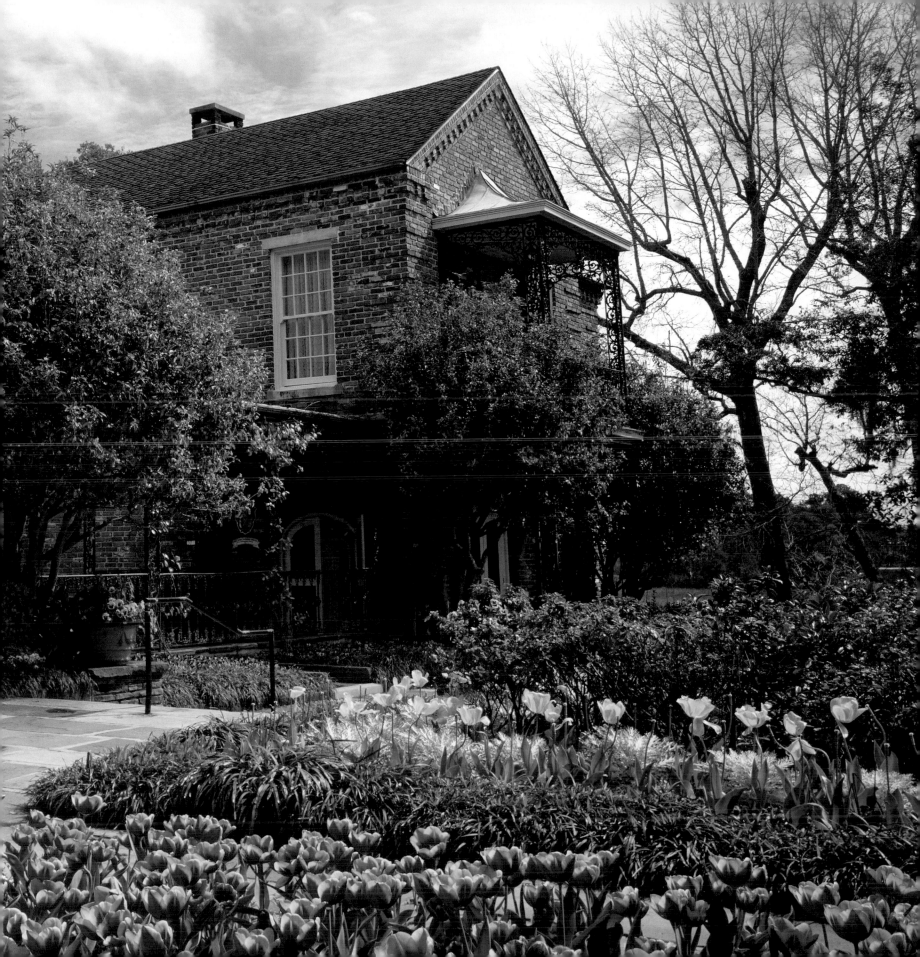

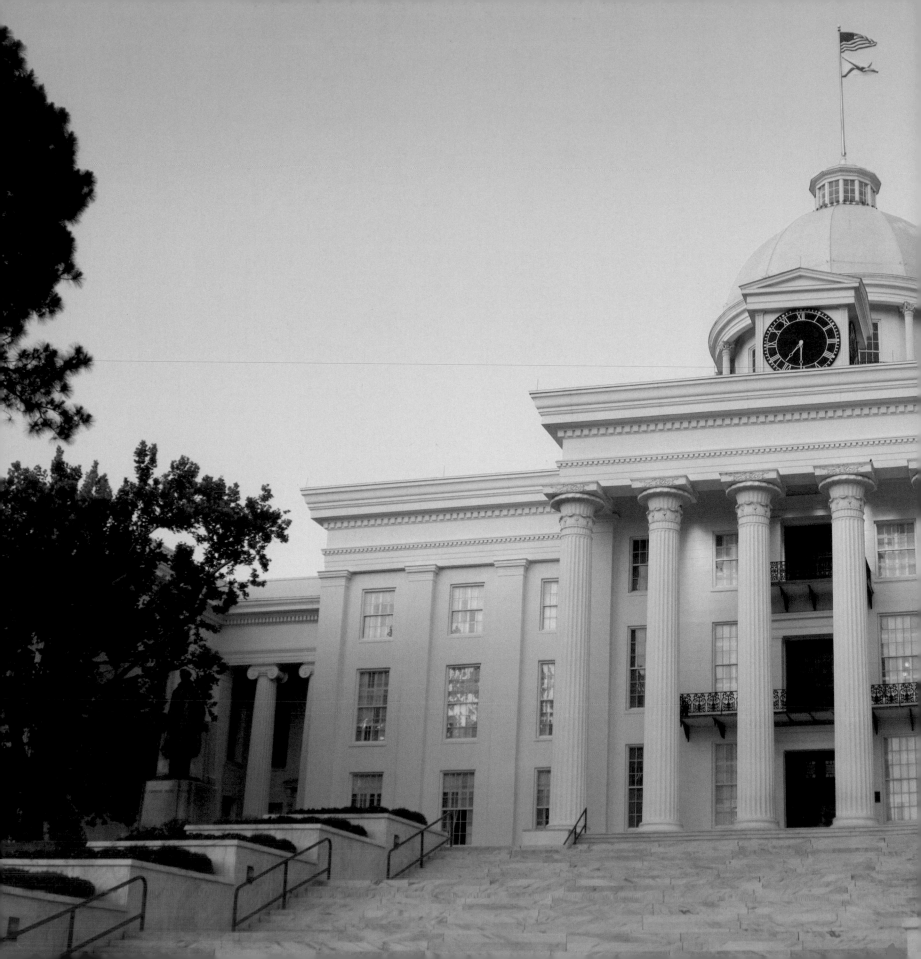

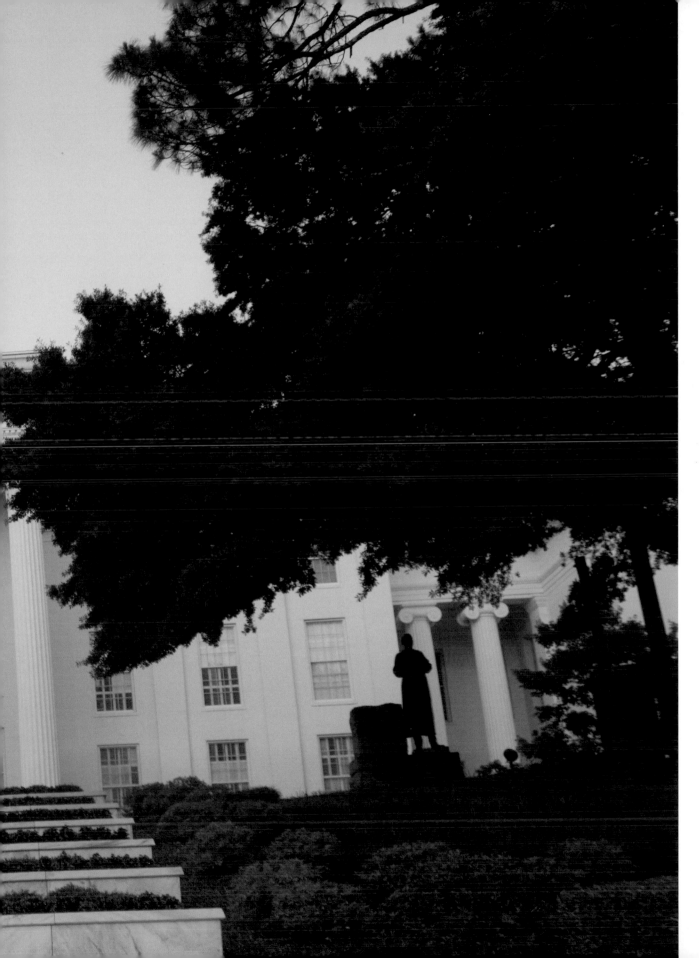

Throughout Alabama's history as both an independent territory and a state, the site of its capital has shifted five times. This stately building is Alabama's second State Capitol since Montgomery was chosen as its capital in 1846. The first was destroyed by fire in 1849. Completed in 1851, this beautiful Greek revival building sits atop Goat Hill.

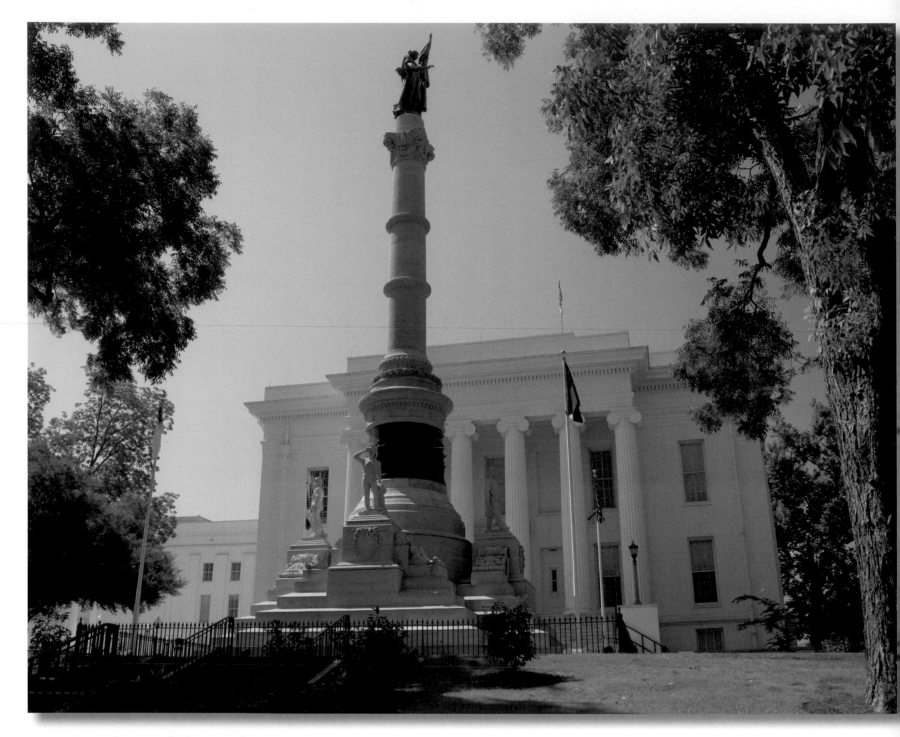

Honoring the Confederacy that was born here in Montgomery and for which the city served as the capital, the Confederate Monument stands on the grounds of the State Capitol. The President of the Confederate States of America, Jefferson Davis, laid this elegant monument's cornerstone in 1886 and it was dedicated in 1898. The monument underwent extensive restoration and was rededicated in 2004.

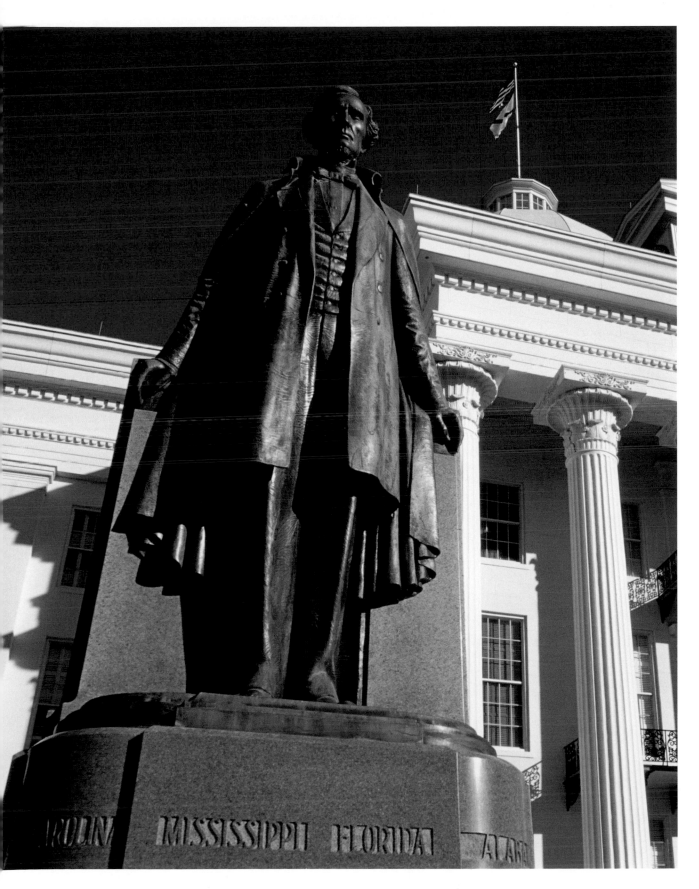

It was at a constitutional convention here in Montgomery, Alabama, that Jefferson Davis was chosen as the President of the Confederate States of America, and on the steps of the Alabama State Capitol that he took the oath of office. A former War Secretary of the United States, Davis was the only leader of the Confederate union, which lasted from 1861–1865.

Thousands of square feet of exterior glass make the Arthur R. Outlaw Convention Center in Mobile, Alabama, a truly stunning structure. With atriums, terraces, a grand ballroom, and multiple meeting rooms, this sprawling state-of-the-art facility is a beautiful modern addition to historic Mobile.

30

A museum offering a glimpse into 19th-century America, this restored Italianate mansion once served as the home of Jefferson Davis, the only leader of the Confederate States of America. The First White House of the Confederacy was completely restored in 1921 and moved here, 10 blocks from its original site. The museum is furnished with authentic pieces from the Davis era.

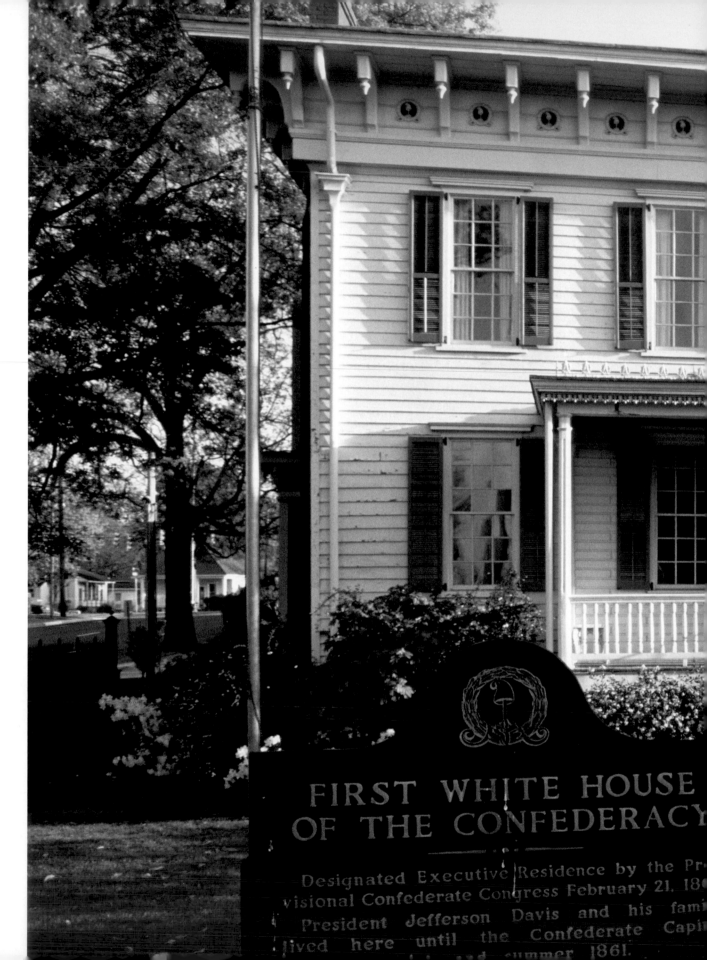

FIRST WHITE HOUSE
OF THE CONFEDERACY

Designated Executive Residence by the Pr
visional Confederate Congress February 21, 18
President Jefferson Davis and his fami
lived here until the Confederate Capi
summer 1861.

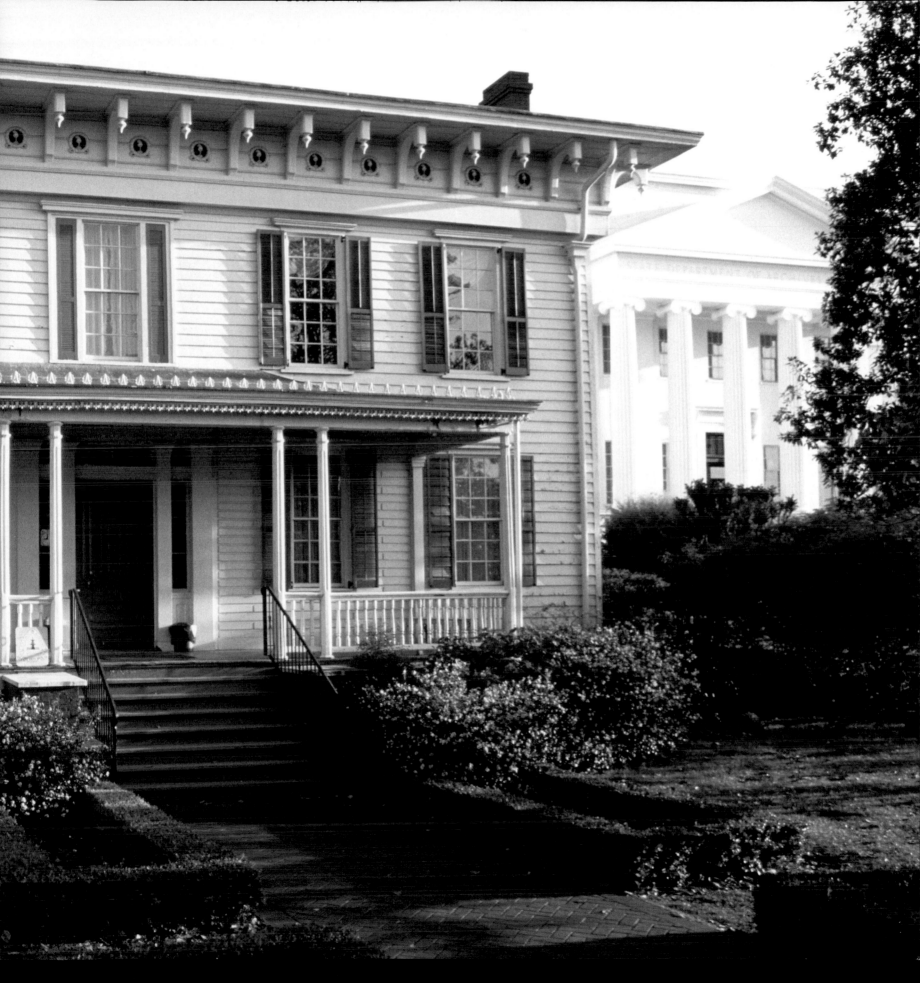

At the turn of the last century Alabamian children would have attended school in one-room schoolhouses much like this one on display at Old Alabama Town in Montgomery. This restored pioneer settlement illuminates the way of life in early 19th-century Alabama through the authentic schoolhouse, corner store, doctor's office, and church.

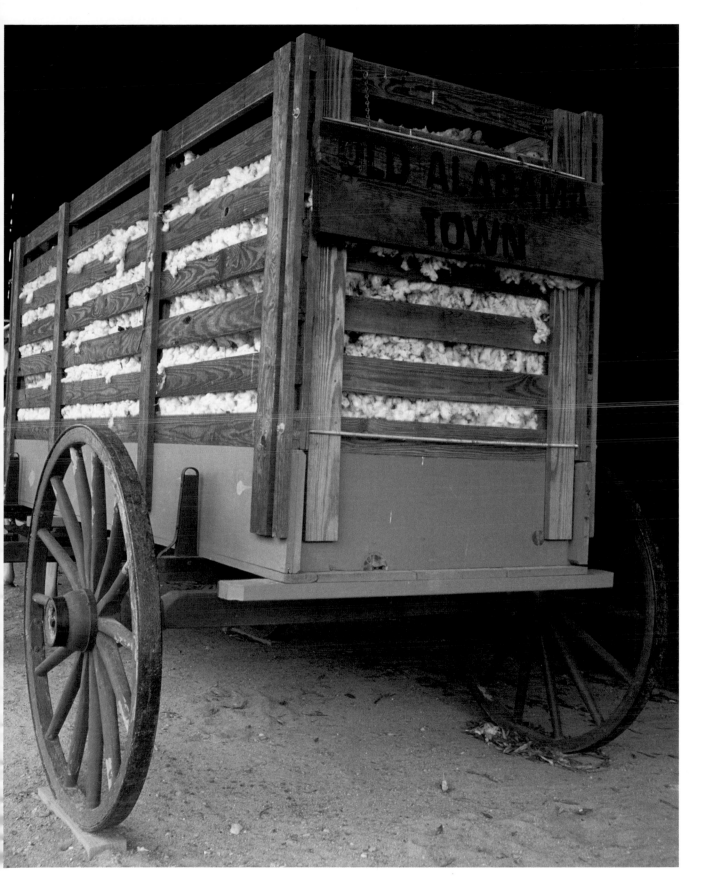

This cart full of fresh cotton at Old Alabama Town represents an important aspect of Alabama's past and present. Cotton was key in developing the state's economy, and Alabama remains one of the top cotton producers in the United States. A turn-of-the-century cotton gin was capable of producing about two bales of cotton per hour, a far cry from the bale per minute of modern models.

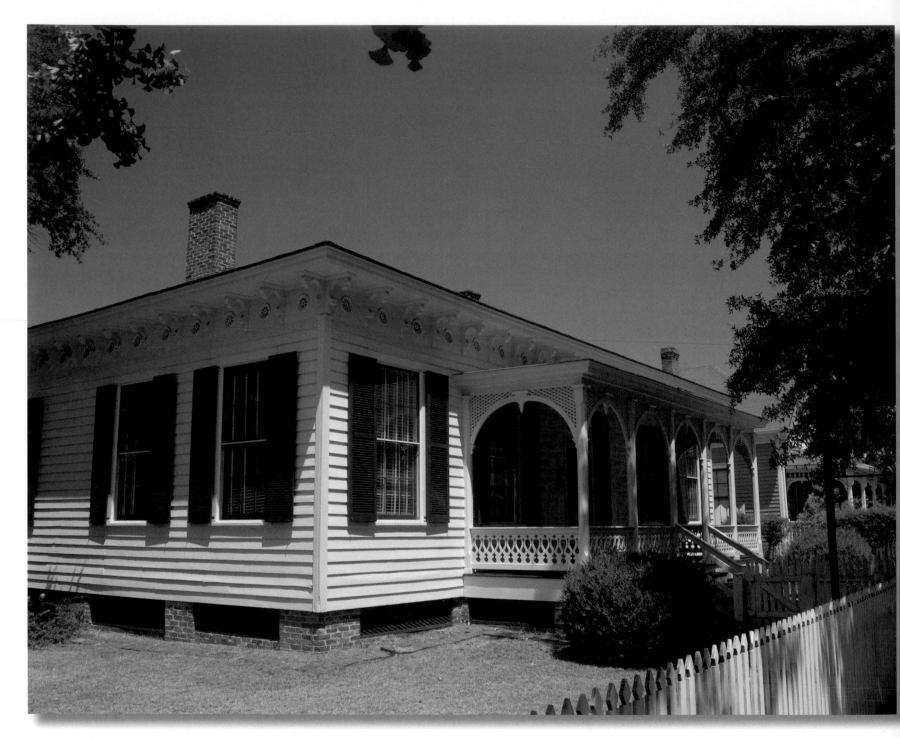

This Italianate cottage is part of Old Alabama Town, which stretches over six blocks in downtown Montgomery. Built in the middle of the 19th century by Thomas DeWolfe, the DeWolfe-Cooper Cottage features detailed gothic trimmings.

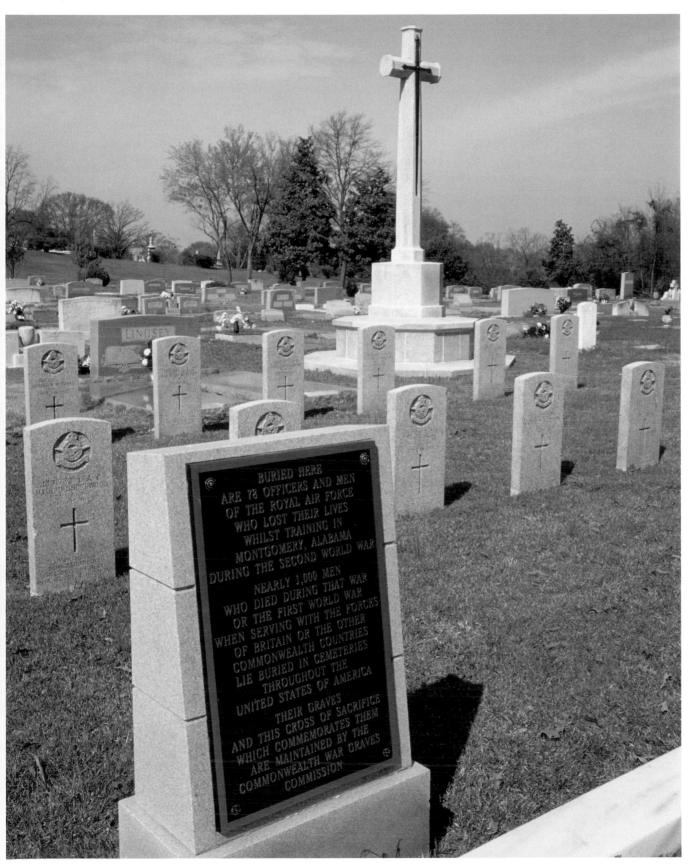

BURIED HERE
ARE 78 OFFICERS AND MEN
OF THE ROYAL AIR FORCE
WHO LOST THEIR LIVES
WHILST TRAINING IN
MONTGOMERY, ALABAMA
DURING THE SECOND WORLD WAR

NEARLY 1,000 MEN
WHO DIED DURING THAT WAR
OR THE FIRST WORLD WAR
WHEN SERVING WITH THE FORCES
OF BRITAIN OR THE OTHER
COMMONWEALTH COUNTRIES
LIE BURIED IN CEMETERIES
THROUGHOUT THE
UNITED STATES OF AMERICA

THEIR GRAVES
AND THIS CROSS OF SACRIFICE
WHICH COMMEMORATES THEM
ARE MAINTAINED BY THE
COMMONWEALTH WAR GRAVES
COMMISSION

A cluster of graves and a monument at the Oakwood Annex Cemetery in Montgomery honor the 78 members of Britain's Royal Air Force who perished here during World War II training exercises. Hundreds of thousands of Alabamians fought in World War II, and the state also housed over 17,000 people in four prisoner of war camps from 1943 – 1945.

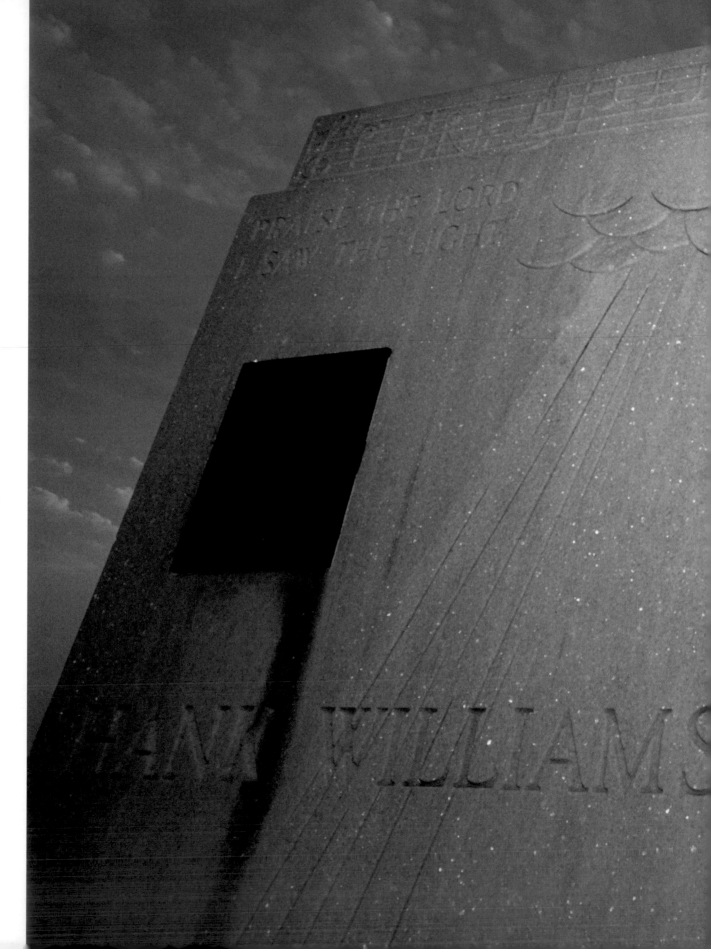

One of Alabama's most iconic figures, musician Hank Williams is credited with changing the face of country music and honky tonk. Memorialized at the Oakwood Annex Cemetery here in Montgomery, the singer who recorded 12 number one hits by the time of his death at the age of 29 is celebrated with the Hank Williams Festival every June. The singer's 1953 funeral is said to be the largest Alabama has ever seen.

Established in 1930 by local artists and art lovers, the Museum of Fine Arts in Montgomery is Alabama's oldest fine art museum. The museum moved into this stately building in the Wynton M. Blount Cultural Park in 1988 — a fitting structure to display its renowned collections of 19th- and 20th-century American paintings, Southern regional art, and old master prints.

41

27 FEB 1967 ... CIVIL RIGHTS LEADER KILLED FOR HIS OPPOSITION TO WHITE JOB ... NATCHEZ, MS

10 JUL 1966 CLARENCE TRIGGS SLAIN BY NIGHTRIDER BOGALUSA, LA

10 JUN 1966 BEN CHESTER WHITE KILLED BY KLAN NATCHEZ, MS

10 JAN 1966 VERNON DAHMER BLACK COMMUNITY LEADER KILLED IN KLAN BOMBING HATTIESBURG, MS

3 JAN 1966 SAMUEL YOUNGE JR STUDENT CIVIL RIGHTS ACTIVIST KILLED IN DISPUTE OVER WHITE ONLY RESTROOM TUSKEGEE, AL

20 AUG 1965 JONATHAN DANIELS SEMINARY STUDENT KILLED BY DEPUTY HAYNEVILLE, AL

18 JUL 1965 WILLIE WALLACE BREWSTER KILLED BY NIGHTRIDERS ANNISTON, AL

CONGRESS PASSES VOTING RIGHTS ACT OF 1965

9 JUL 1965 ONEAL MOORE BLACK DEPUTY KILLED BY NIGHTRIDERS VARNADO, LA

2 JUN 1965 VIOLA GREGG LIUZZO KILLED BY KLAN WHILE TRANSPORTING MARCHERS SELMA HIGHWAY, AL

... RIGHTS MARCH FROM SELMA TO ... GOMERY COMPLETED

... REEB ...

...UNTIL JUSTICE ROLLS DOWN LIKE WATERS
AND RIGHTEOUSNESS LIKE A MIGHTY STREAM

MARTIN LUTHER KING JR

This civil rights memorial in Montgomery honors the people who died during the struggle for equality for African Americans from 1954 – 1968 — starting with the year when segregation in schools was deemed unlawful and ending with the year of the assassination of Dr. Martin Luther King Jr. Sponsored by the Southern Poverty Law Center and created by artist Maya Lin, the memorial bears quotes from King's "I Have a Dream" speech.

43

Civil rights activist Dr. Martin Luther King Jr. served as the pastor here at the Dexter Avenue King Memorial Church in Montgomery from 1954 – 1960. King's crusade for equality is depicted in a large mural inside this National Historic Landmark.

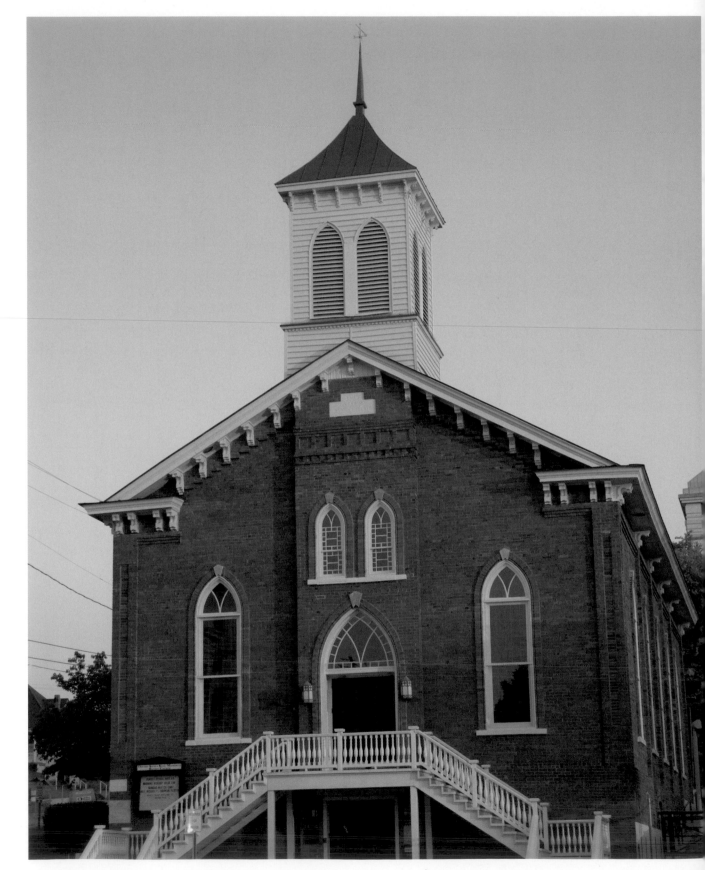

An important establishment in a state that has struggled with race relations, the Southern Poverty Law Center combats racism and promotes civil rights. Founded in 1971 as a civil rights law firm, this non-profit center aims to teach tolerance, work against hate groups and supremacists, and represent victims of racially motivated violence.

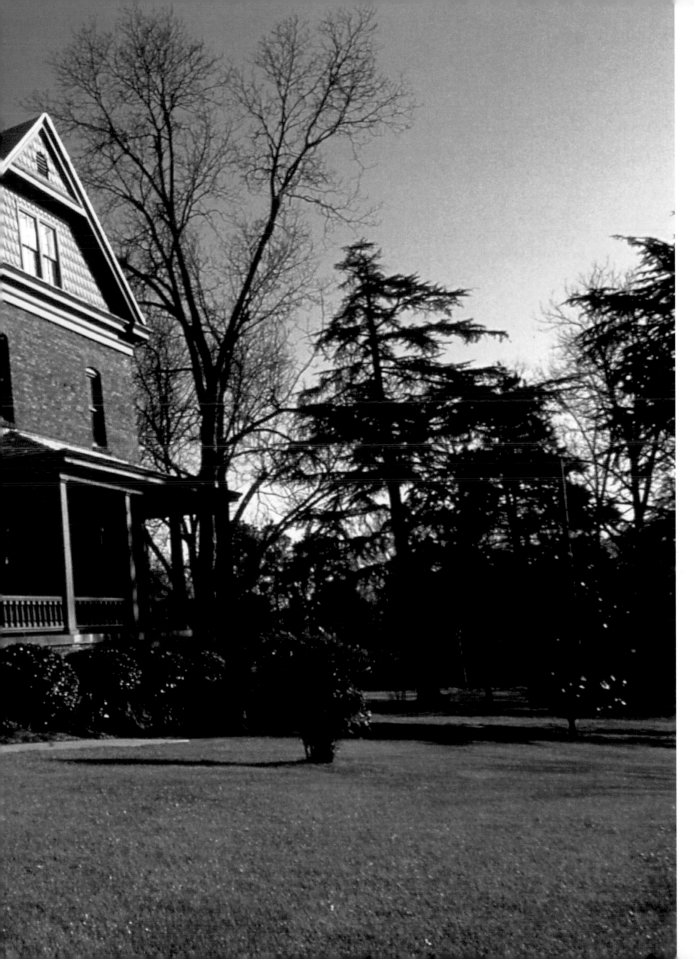

Built as a home for
Booker T. Washington
and as the center
of the Tuskegee
Institute, The Oaks
was completed in
1900 by Institute
students and faculty.
Washington was an
educator, author, and
prominent leader in
the African-American
community who was
the first leader of
the teacher training
school that became
Tuskegee University.
In the interest of
imparting the tools
for independence,
Washington also
taught his students
agricultural, domestic,
and building skills.

Streets lined with restored buildings, like this riverfront hotel, and lavish antebellum mansions make the City of Selma one of Alabama's largest historic districts. According to legend, Selma was built on the spot where Chief Tuskaloosa encountered Spanish explorer Hernando deSoto — a meeting that would lead to the Battle of Mabila in 1540. Over 400 years later in 1965, Selma became the starting point for the infamous Selma to Montgomery marches in support of the civil rights movement.

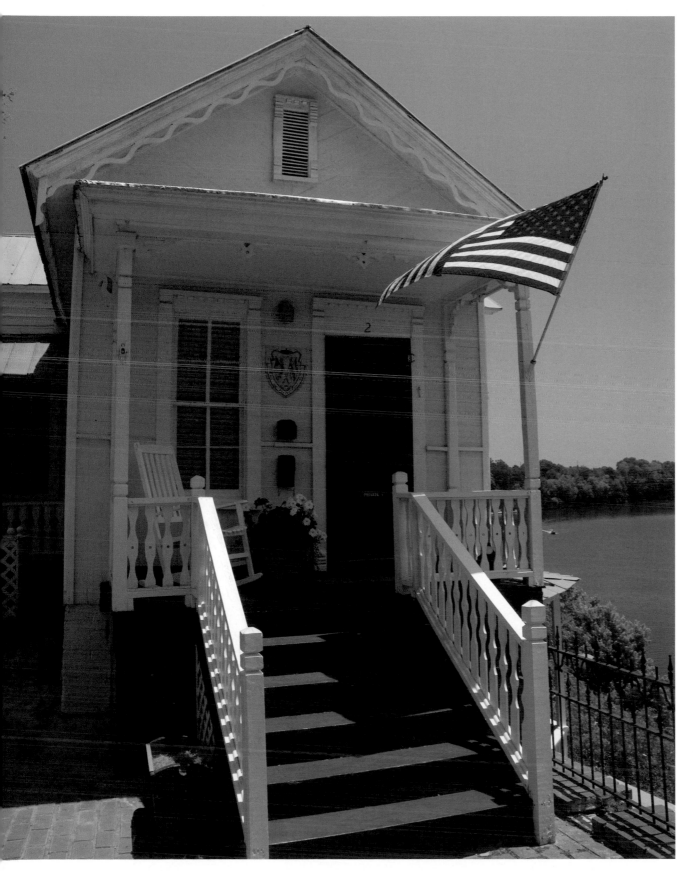

Nestled into Selma's Water Avenue Historic District, this little house is perched on the banks of the Alabama River. The Alabama River's name comes from two Choctaw words: *alba*, which roughly translates to vegetation, and *amo*, meaning gather. The state was named after the Alabama River.

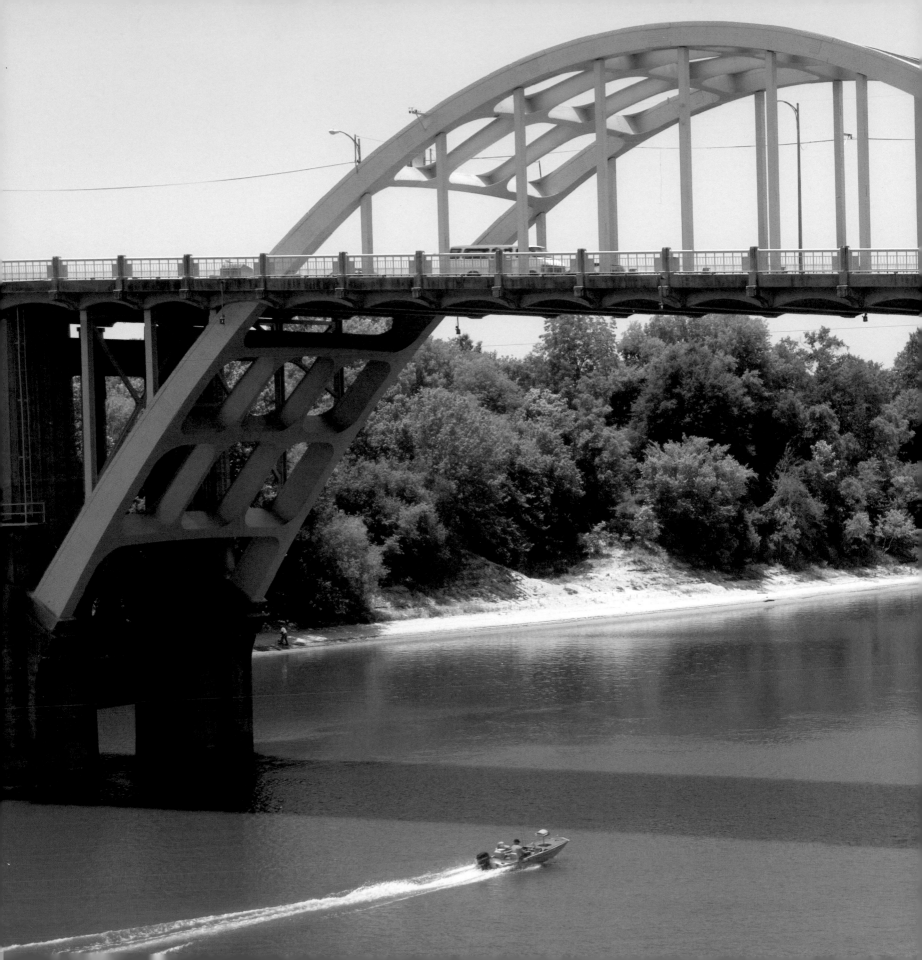

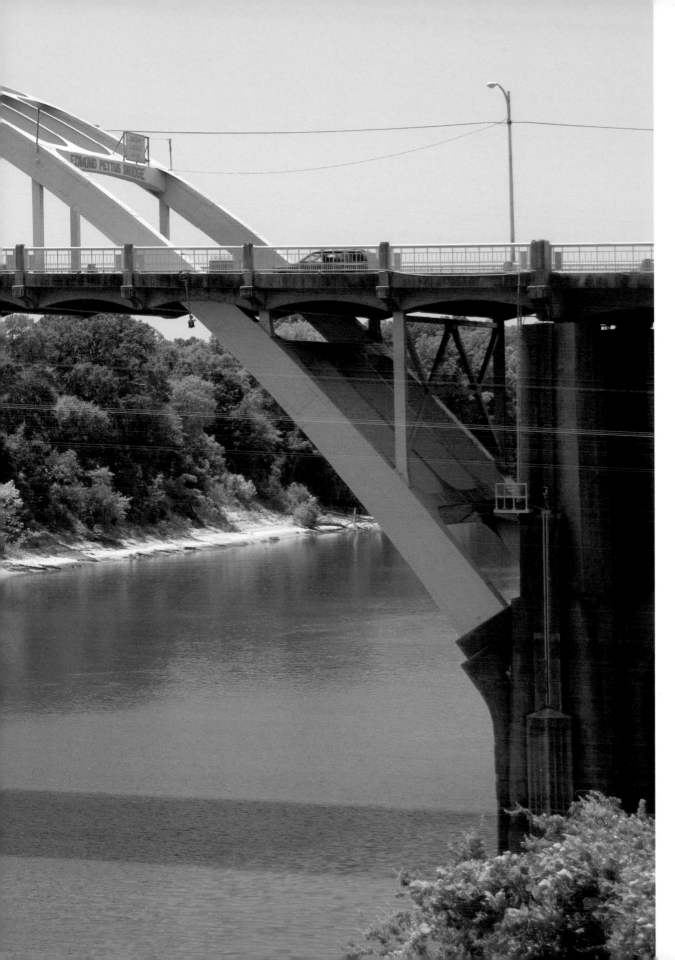

Spanning the Alabama River, the Edmund Pettus Bride is part of the Selma to Montgomery National Historic Trail. It was on this bridge in 1965 that police attacked 600 people marching to Montgomery in support of African American voting rights, in what became known as the Bloody Sunday battle. Another unsuccessful march to Montgomery followed before the third and final march made it through to Alabama's capital. Five months after this third march, President Lyndon Johnson signed the Voting Rights Act of 1965.

The Brown Chapel African Methodist Episcopal Church was the starting point for the Selma to Montgomery marches that are credited with leading to the Voting Rights Act of 1965. This Romanesque revival building was often used as meeting headquarters during the civil rights movement. Its front lawn now bears a monument to Dr. Martin Luther King Jr.

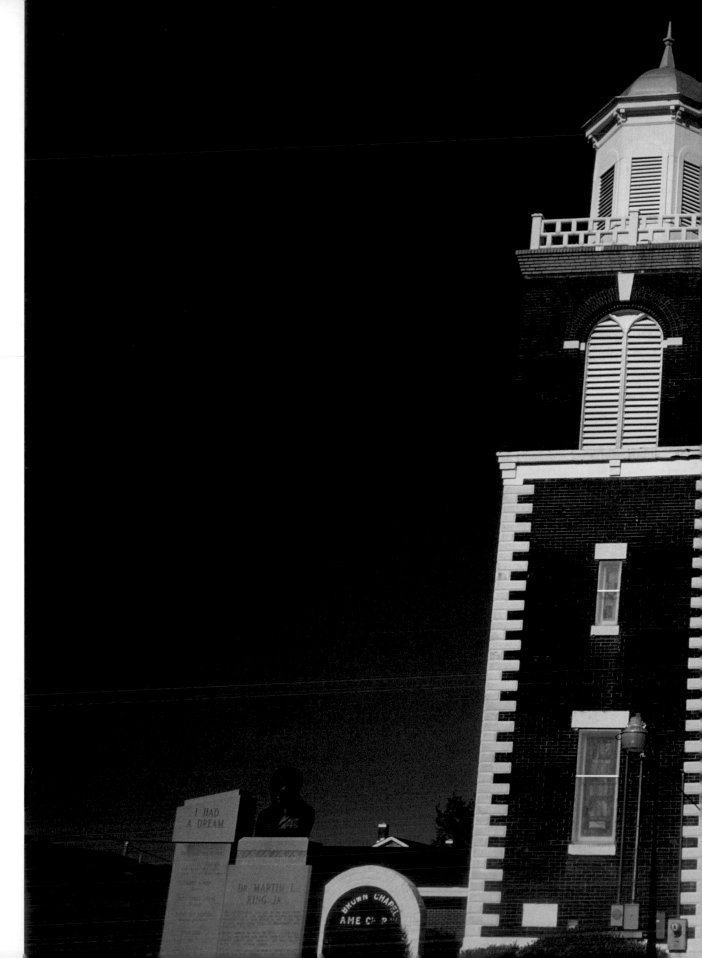

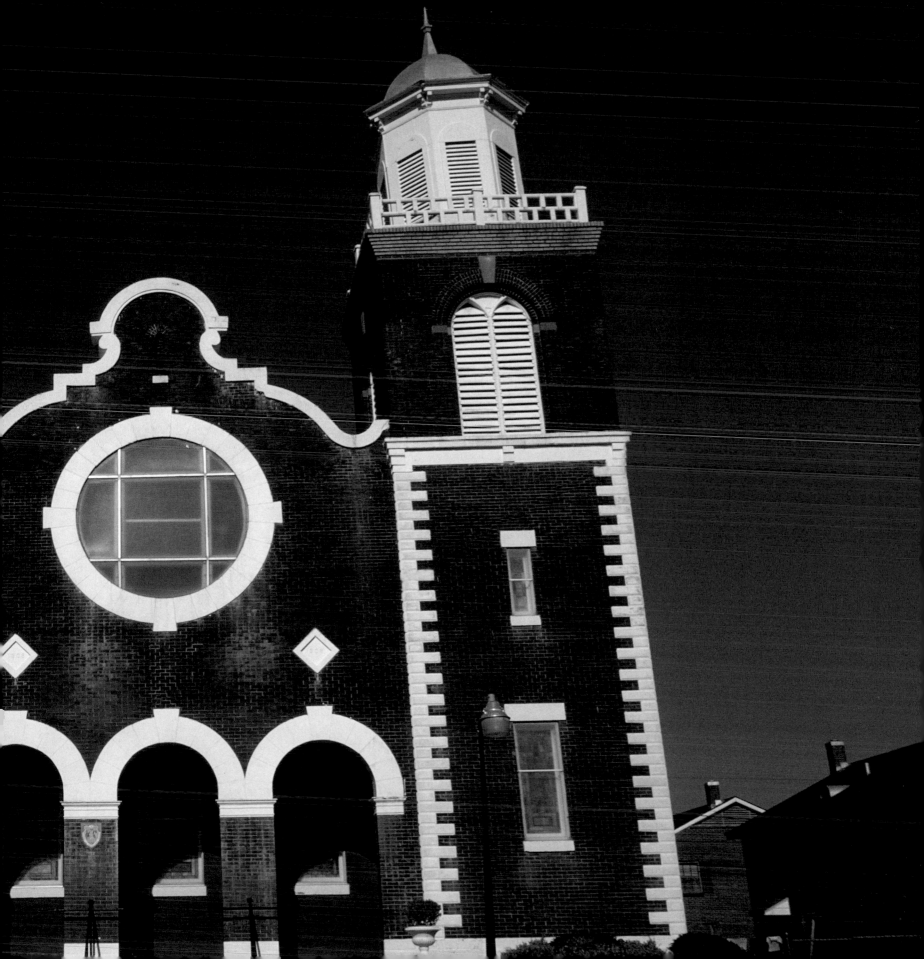

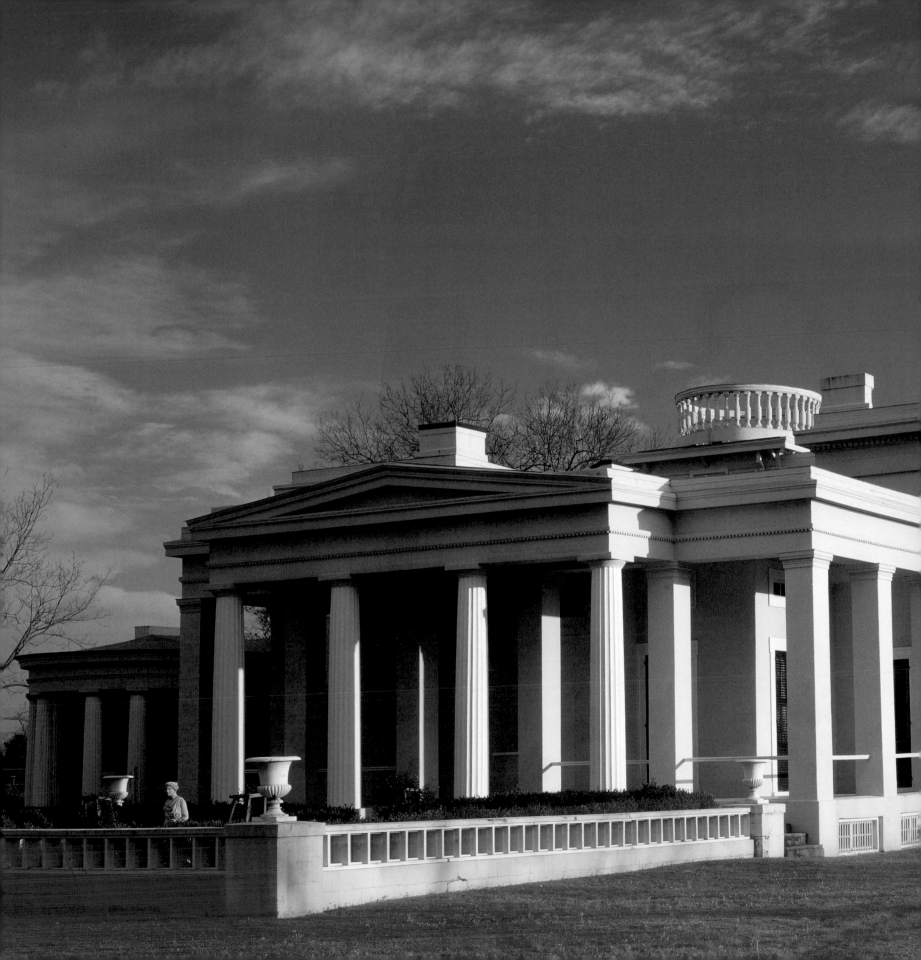

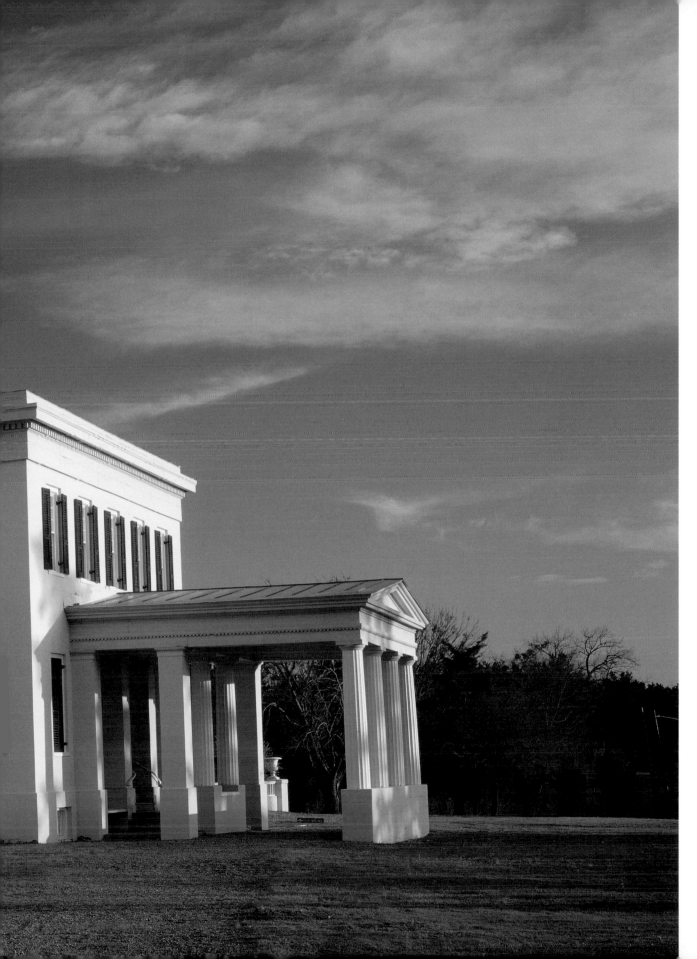

An exceptional example of Greek revival architecture in America, Gaineswood mansion was completed in 1861. This National Historic Site in Demopolis was named after George Strother Gaines who built the first cabin on this land, which now provides the foundations for this historic home. Gaines was instrumental in the development of Demopolis: he encouraged the French to invest in the area in the early 19th century.

A fitting structure for Alabama's premiere peach-producing district, this water tower soars above the many fruit stands in Chilton County. At 120 feet, this peachy tower holds 50,000 gallons of water — a large structure for the small town of Clanton. With its temperate climate, Chilton County is perfect for peach growing, and the bountiful fruit provides an economic stronghold. During peak production the county had about 10,000 acres of orchard.

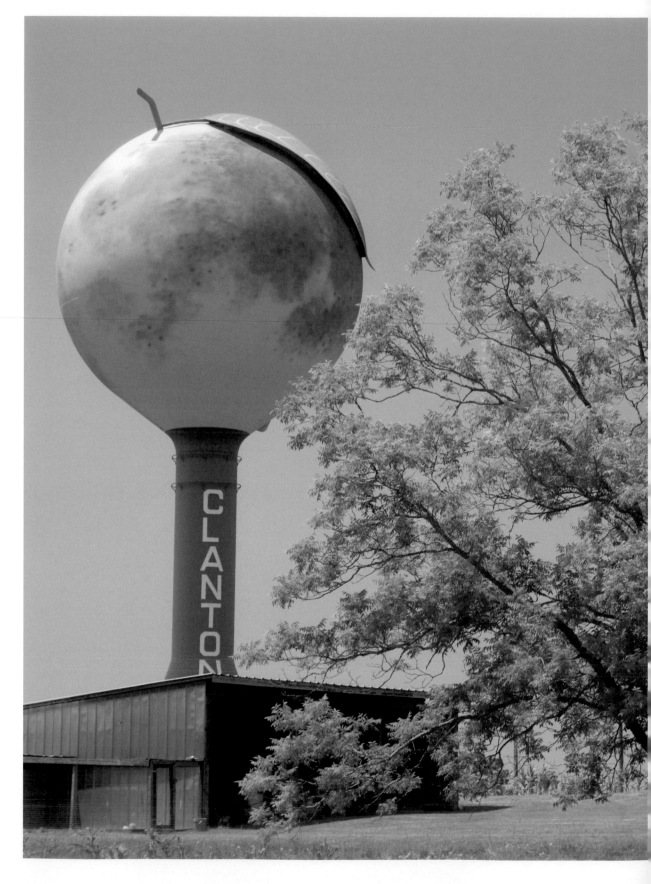

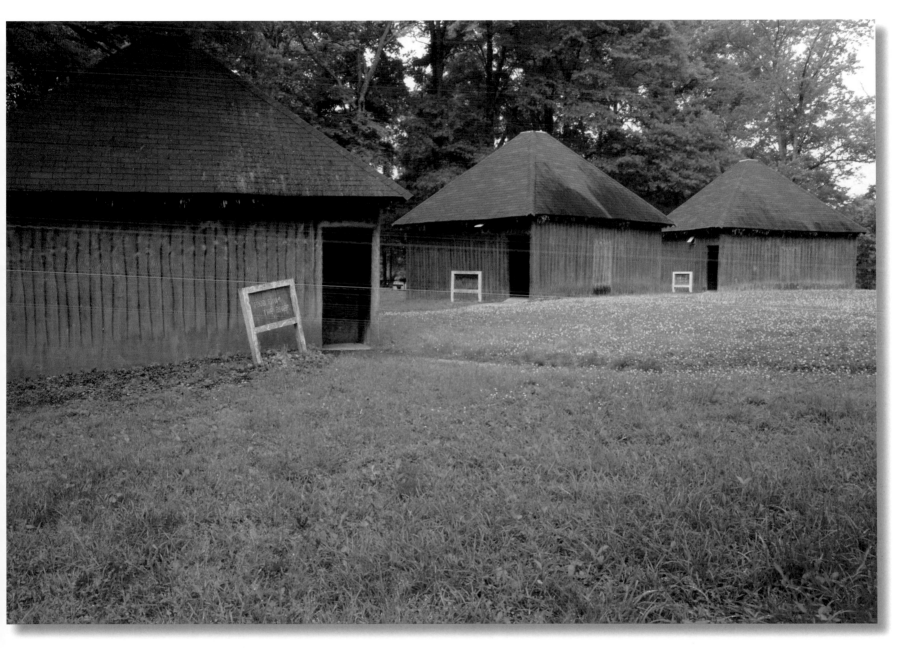

These Indian huts at the Moundville Archeological Park in Tuscaloosa are authentic reproductions of structures from over a thousand years ago. Each hut was recreated to demonstrate a different aspect of daily life for the Southeastern tribes that occupied this site from around A.D. 1000 to A.D. 1450.

One of Alabama's most important sectors, the agriculture industry accounts for a sizeable portion of the state's economy, contributing billions of dollars every year. Although the focus of the farming industry in Alabama is shifting from field crops to poultry, livestock, and timber, the state still cultivates hundreds of thousands of acres of farmland.

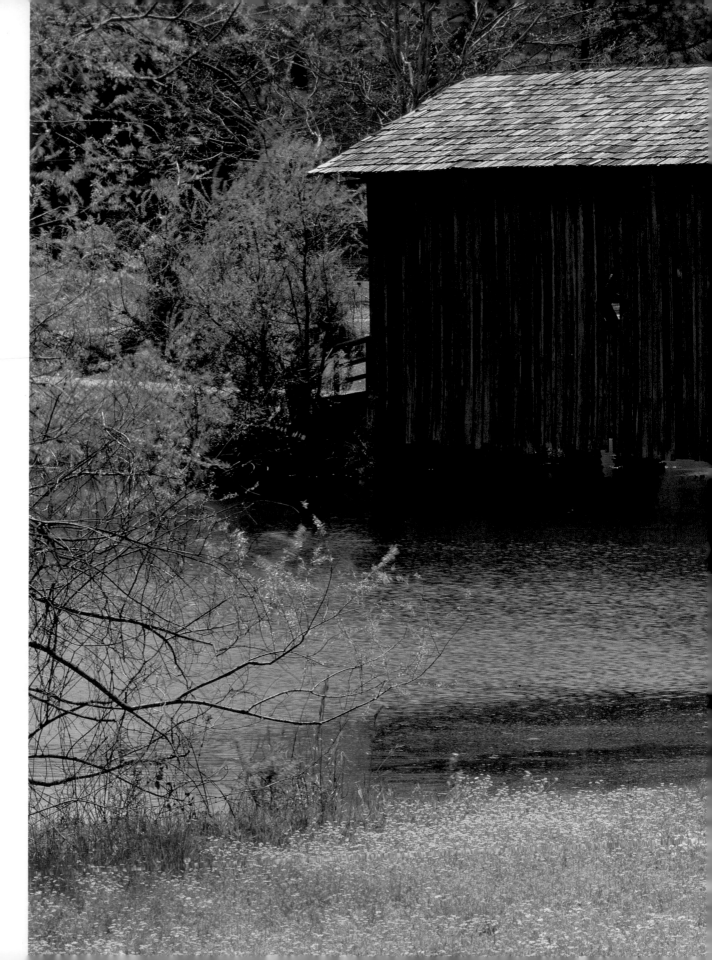

The only remaining covered bridge in West Alabama, the Alamuchee-Bellamy Bridge was originally built over the Surcarnoochee River in 1861 and then moved to Alamuchee Creek. Restored in 1969 and moved a third time here to the University of West Alabama campus, the bridge was used by Confederate soldiers as a pathway into Mississippi during the Civil War.

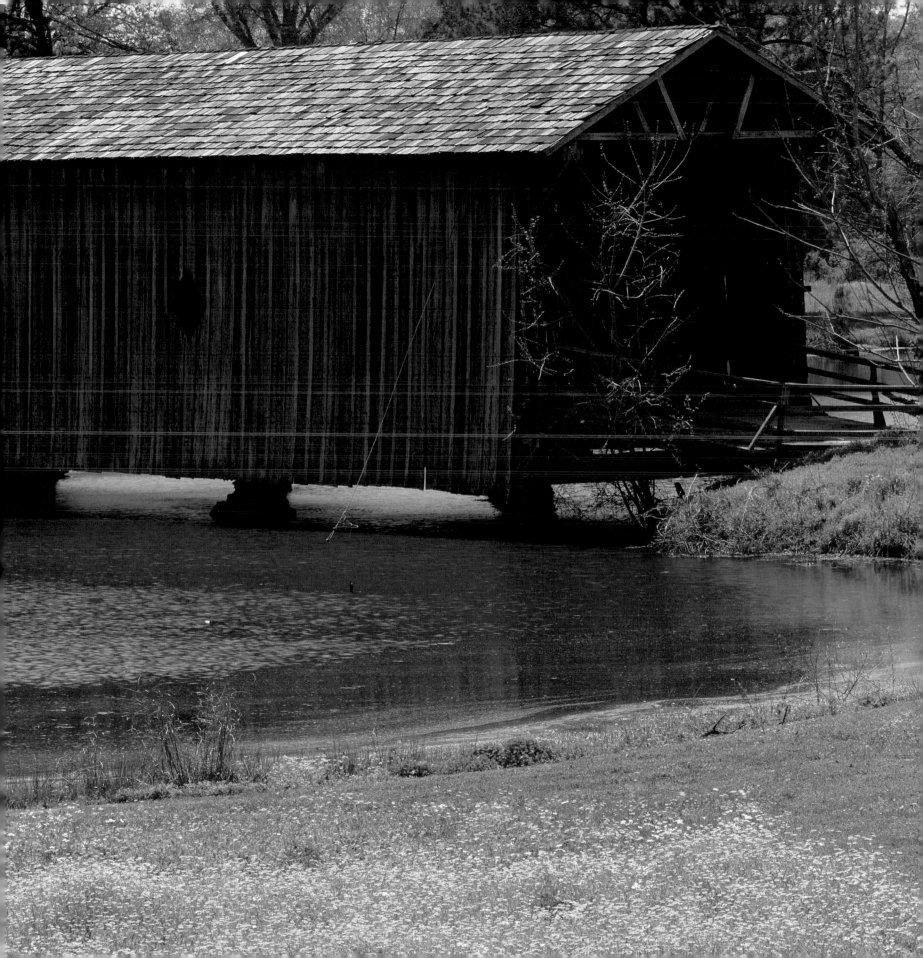

Jutting dramatically
up from Cheaha State
Park, 2,407-foot
Cheaha Mountain
is the highest peak
in Alabama. Part
of the Appalachian
Mountain range and
surrounded by the
Talladega Forest, the
mountain provides an
exquisite lookout to
watch the setting sun.

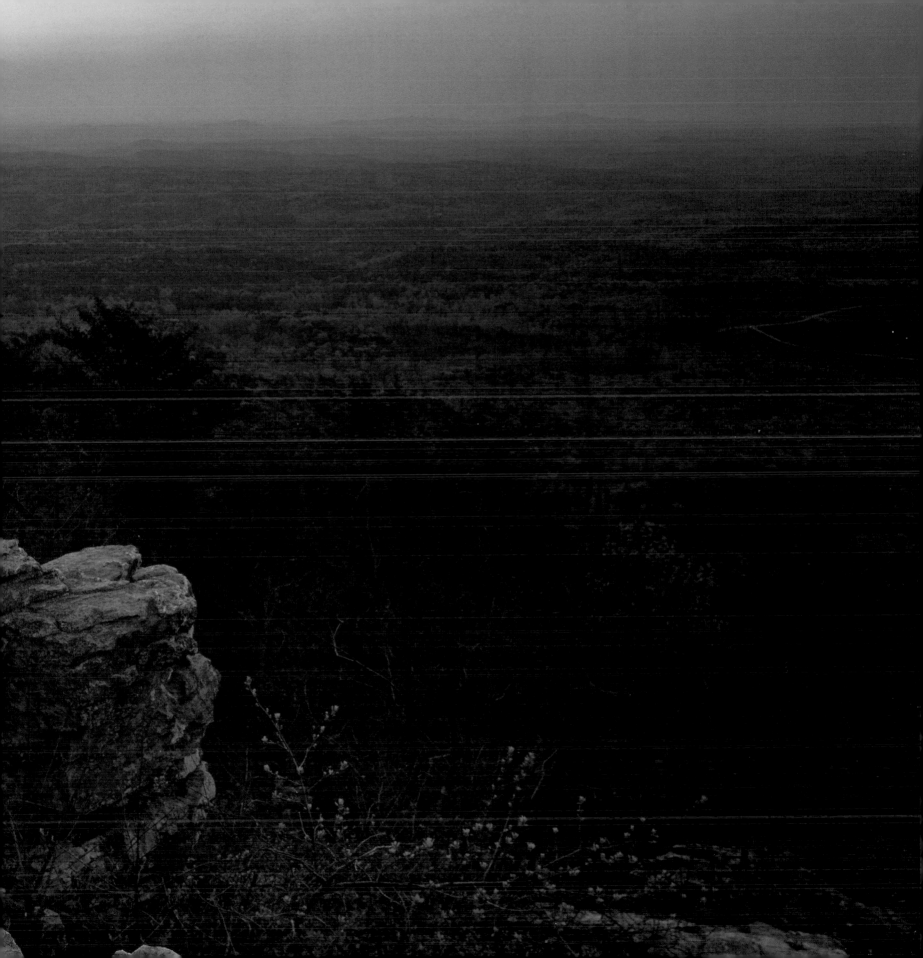

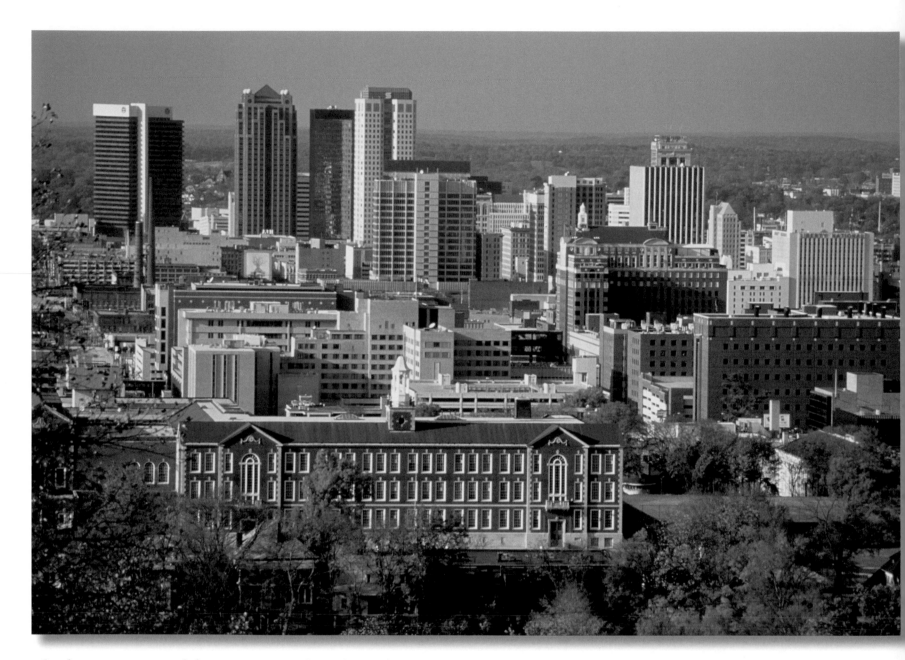

The largest city in Alabama, Birmingham has a history as an industrial center. Its current status as a financial hub has earned it the nickname "magic city." Founded in 1871 and named after Britain's biggest industrial city, Birmingham has become one of the largest banking centers in America. However, the city's attributes are not all business related: it was an important site of the civil rights movement and has been immortalized through Martin Luther King Jr.'s "Letter from a Birmingham Jail" and poet Dudley Randall's renowned "Ballad of Birmingham."

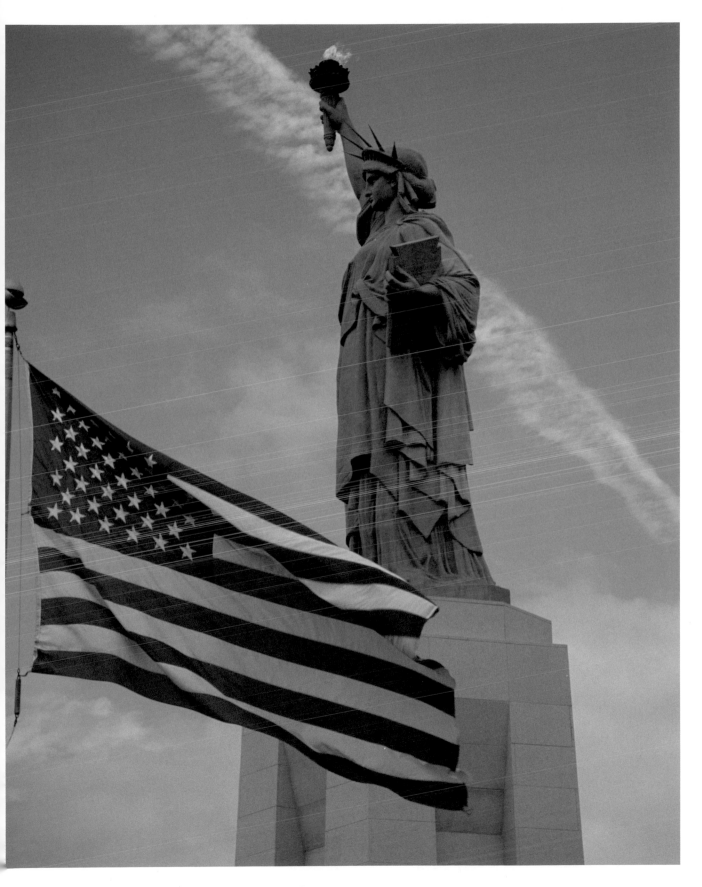

Smaller than her sister in New York but every bit as majestic, this replica of the Statue of Liberty stands in Birmingham's Liberty Park. At 31 feet, Alabama's Lady Liberty is over 100 feet shorter than the original, but still one of the tallest Liberty replicas in the world. Powered by Alabama natural gas, Liberty's torch burns continuously. It has gone out only twice since the statue was brought to Alabama from France in 1958.

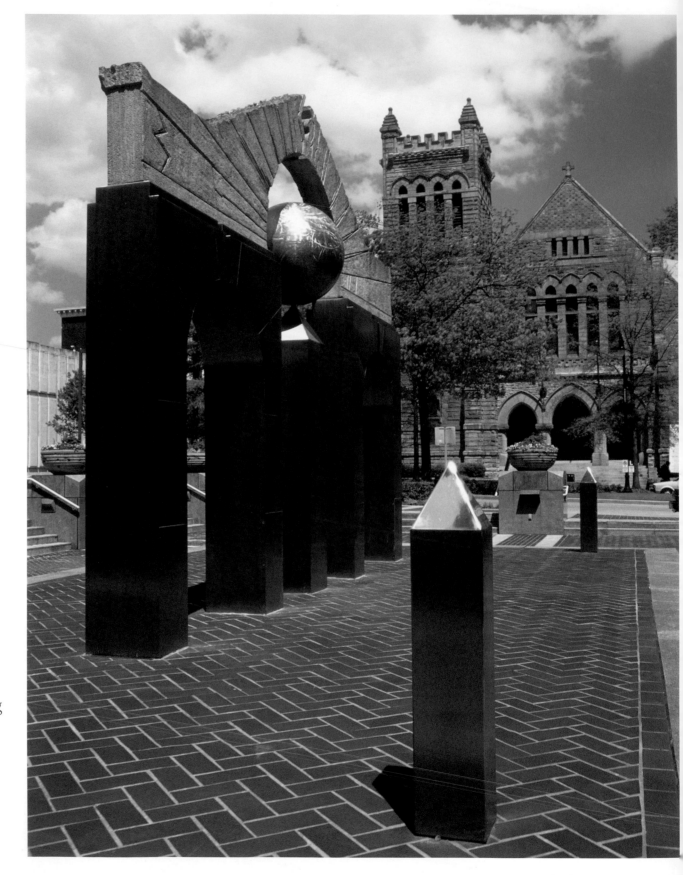

When night falls over bustling Harbert Plaza in Birmingham, moonlight casts a glow over *Alabama Moon*. Featuring a stainless steel obelisk supporting a sphere, Clyde Lynds' modern sculpture symbolizes balance and renewal.

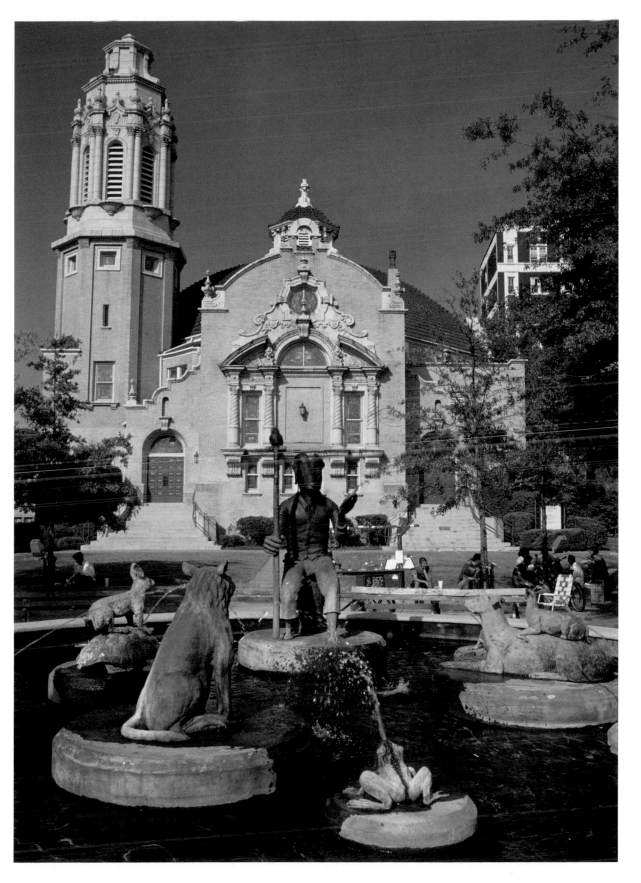

The ornate Highlands United Methodist Church brings a European flavor to Birmingham's Five Points South district. Featuring a figure with the head of a ram and the body of a man reading to small animals, the unique Storyteller Fountain by local artist Frank Fleming stands in front of the gilded church. The fountain represents the importance of sharing stories.

67

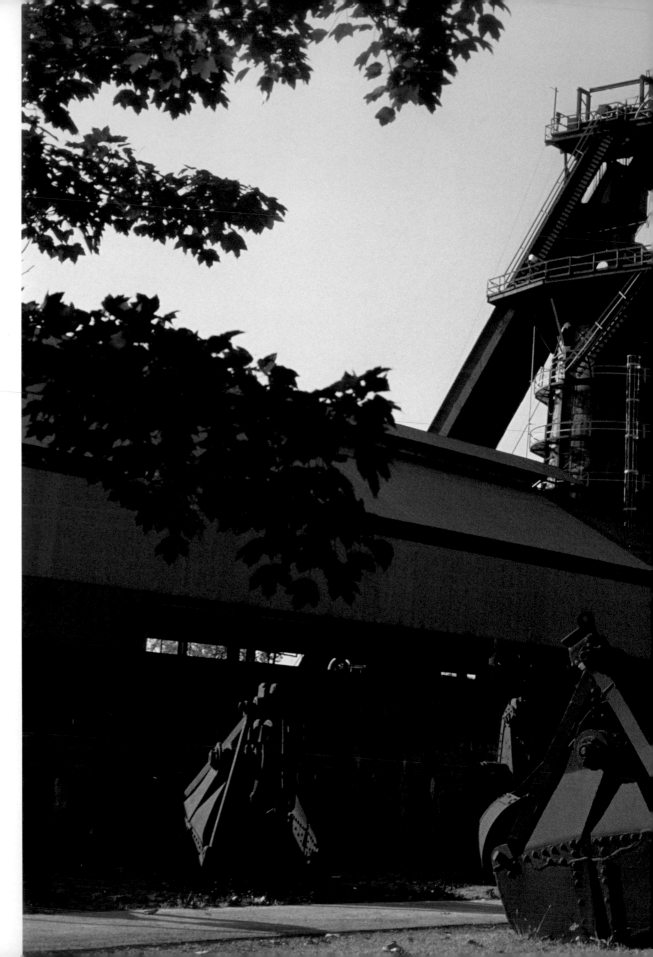

Before closing in 1972, the Sloss Furnaces in Birmingham produced iron for almost a century and also contributed to the development of Alabama's largest city. Now a National Historic Landmark, the Sloss furnaces are one of America's first industrial sites to be conserved and opened to the public. Urban legend has it that the ghosts of the furnace's former workers still wander through its buildings, making its Fright Furnaces festival a major Halloween attraction.

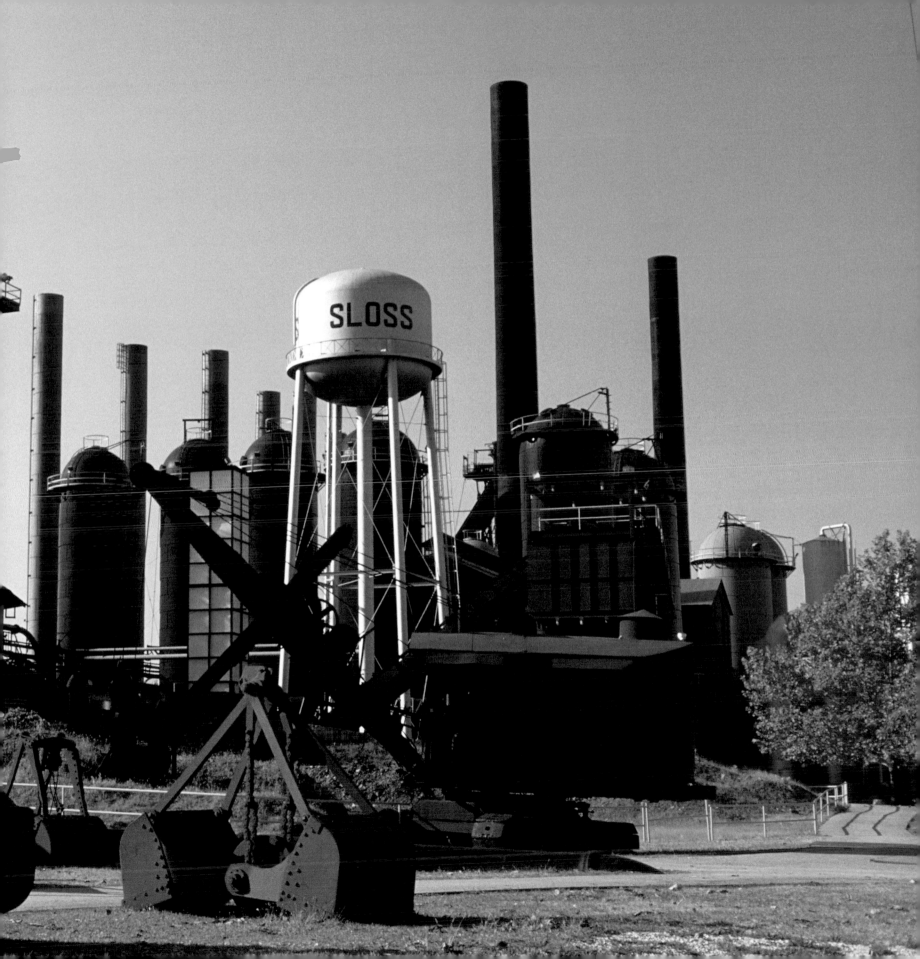

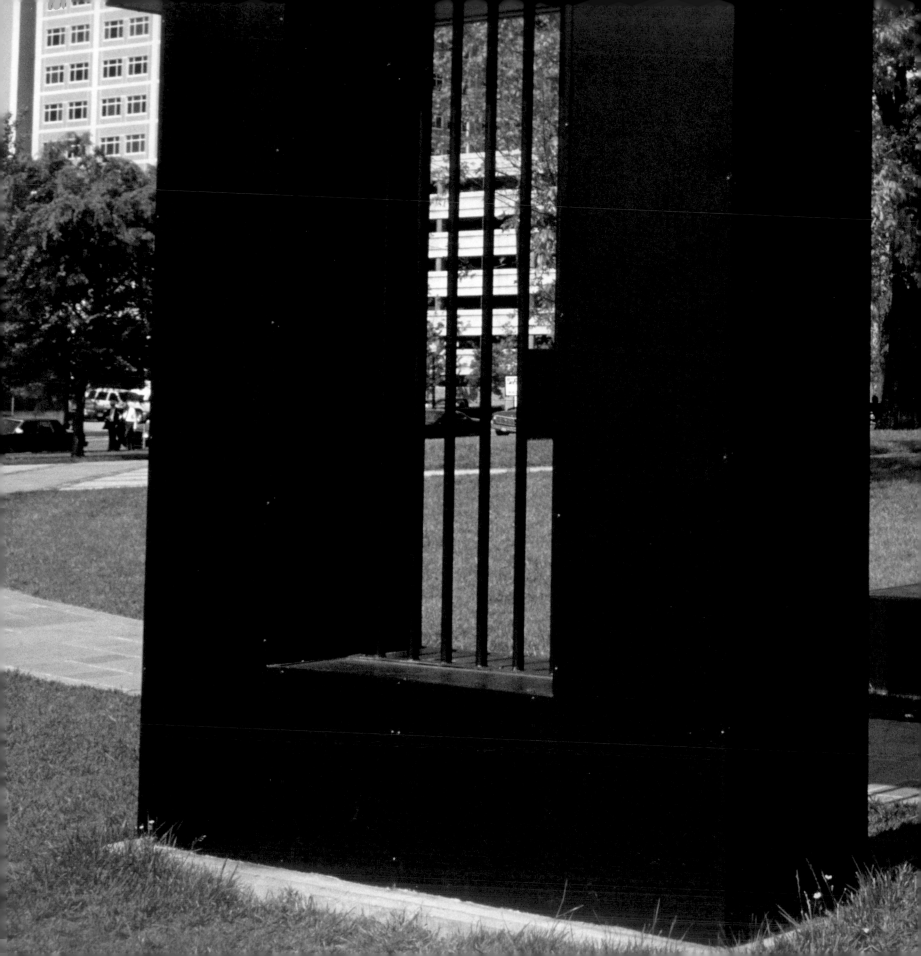

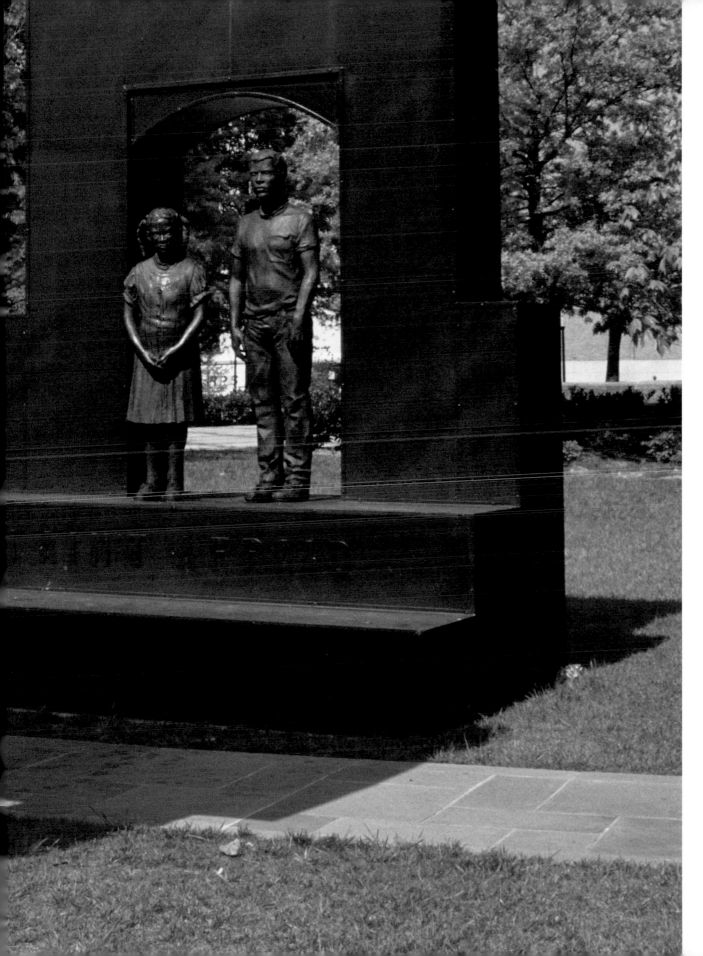

Next to the 16th Street Baptist Church where four girls fell victim to a racially motivated bombing, Kelly Ingram Park features numerous statues commemorating the Civil rights movement. Named for Alabamian Osmond Kelly Ingram — the first American sailor killed in World War I — and the site of massive demonstrations during the 1960s, this park is known as a "place of revolution and reconciliation."

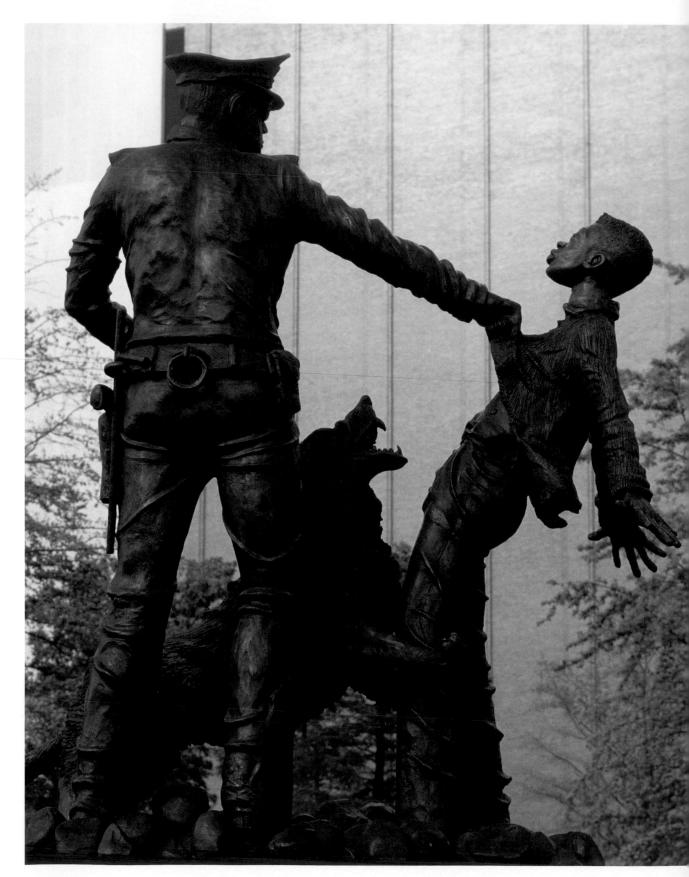

Some disturbing scenes from the climax of the struggle for civil rights in Alabama, and America as a whole, are captured in stone in Kelly Ingram Park. Scenes like this one of a policeman confronting a child that was broadcast on TV news throughout the country compelled America to end segregation and racism.

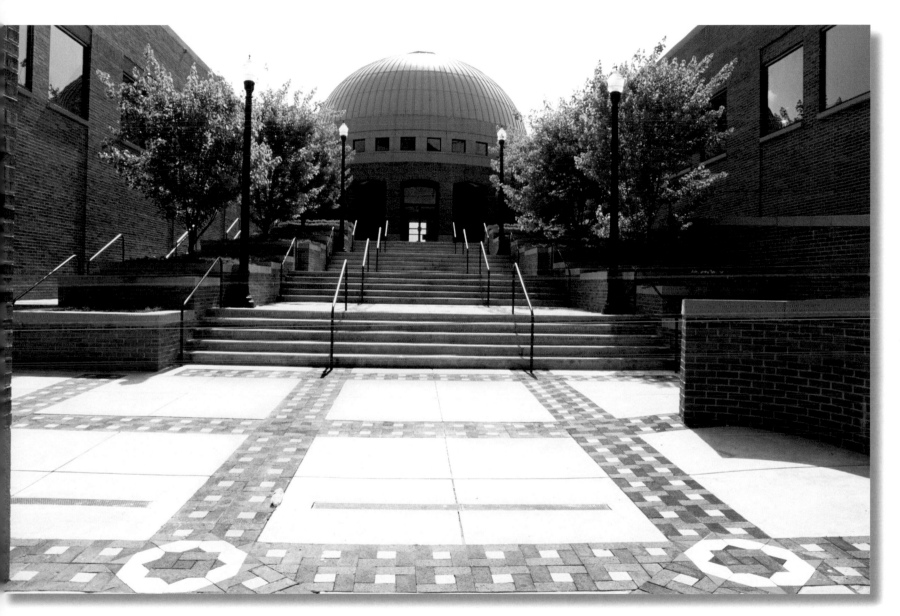

A seminal site of the civil rights movement, Birmingham, Alabama, saw some of the harshest segregation in the country. Dr. Martin Luther King Jr. led many marches through the streets of Birmingham, and it was in a nearby jail that he penned his famous Letter from a Birmingham Jail. Exhibitions dedicated to Rosa Parks, the Selma to Montgomery Marches, and the Freedom Riders here at the Birmingham Civil Rights Institute chronicle the odyssey for equality fought here in the 1960s.

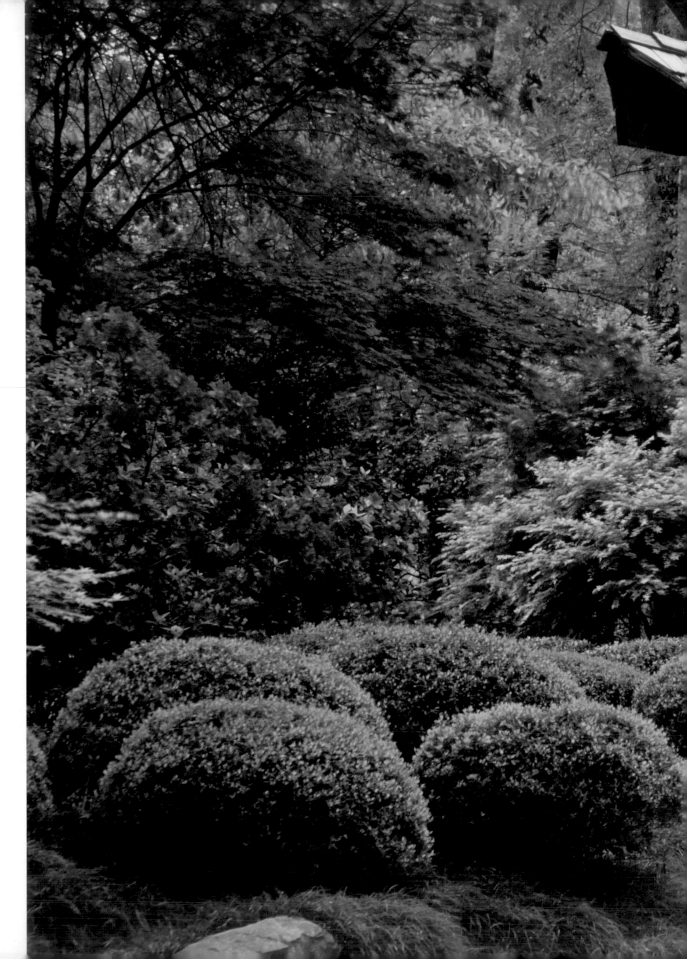

Infusing downtown
Birmingham with
a sense of Zen, this
Japanese garden is one
of 25 display gardens
gracing the 67 acres
of the Birmingham
Botanical Gardens.
Flourishing with
plant species from all
over the world, the
Botanical Gardens is
Alabama's largest living
museum.

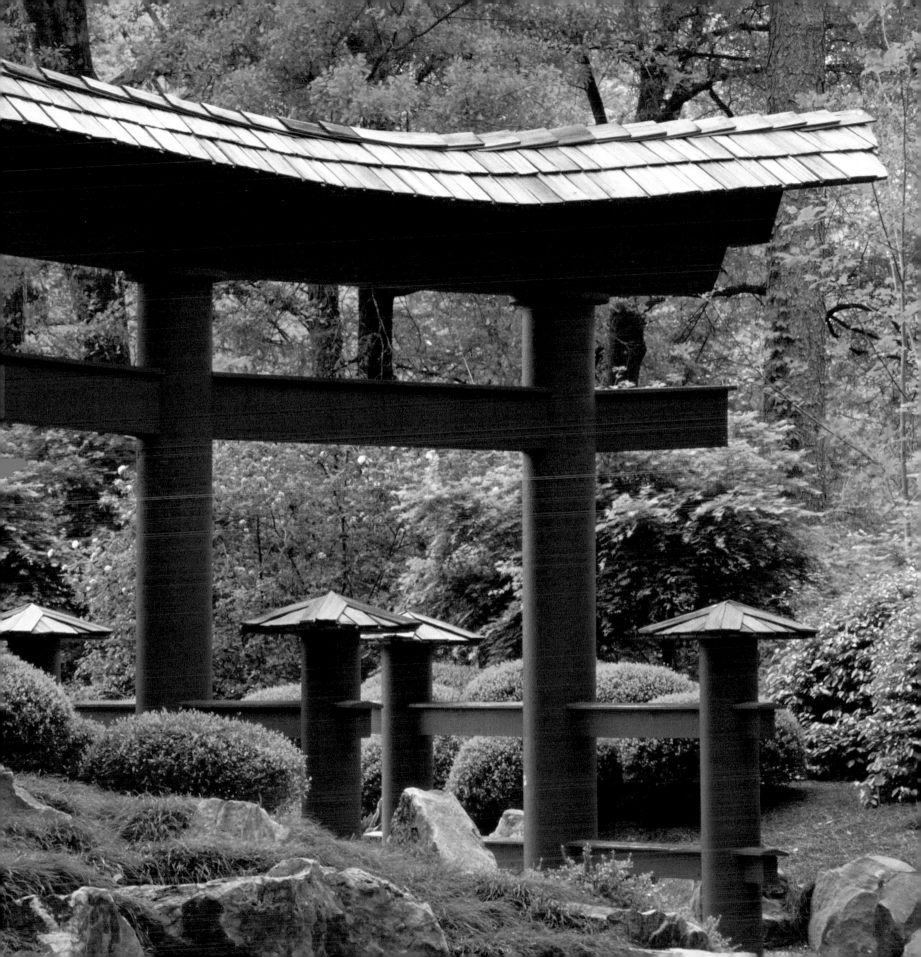

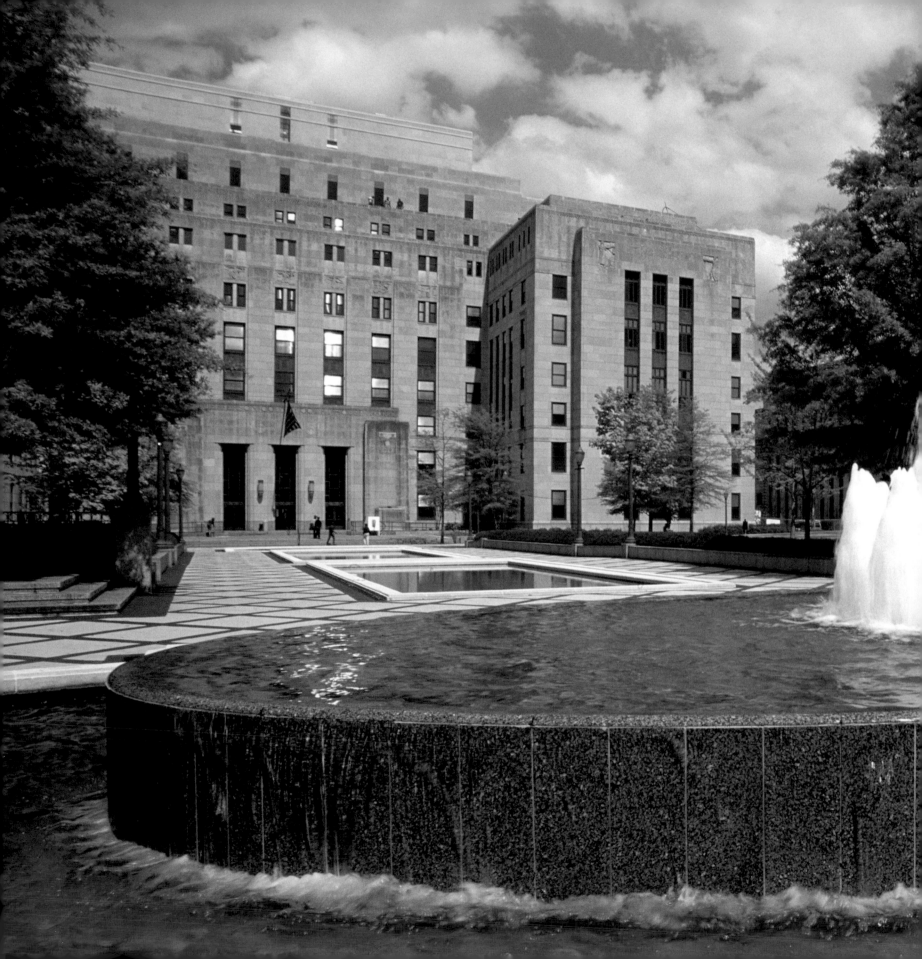

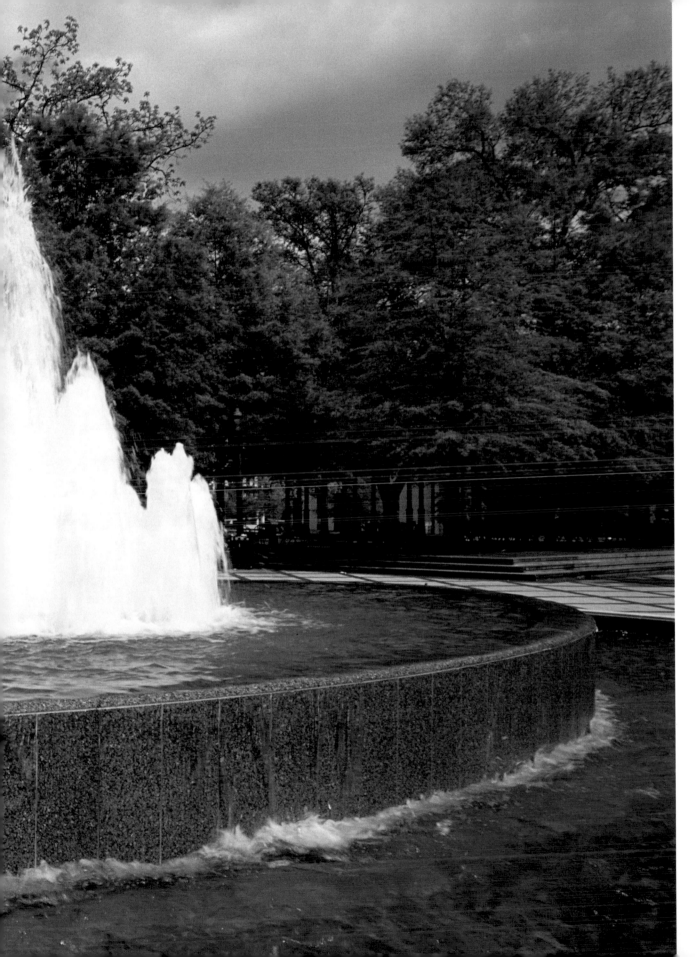

Linn Park and its signature fountain sit outside the imposing art deco-inspired City Hall in Birmingham, the city with over a quarter of Alabama's population. Built in 1950, Birmingham City Hall was soon thrust onto the world stage when it became the site of numerous marches, speeches, and demonstrations during the civil rights movement of the 1960s.

Known as the Iron
Bowl because its host
city of Birmingham
supports a major
iron industry, Legion
Field is home base
for University of
Alabama football
team The Blazers.
Named after the U.S.
veterans association,
the American Legion,
the massive field can
hold an audience of
over 70,000.

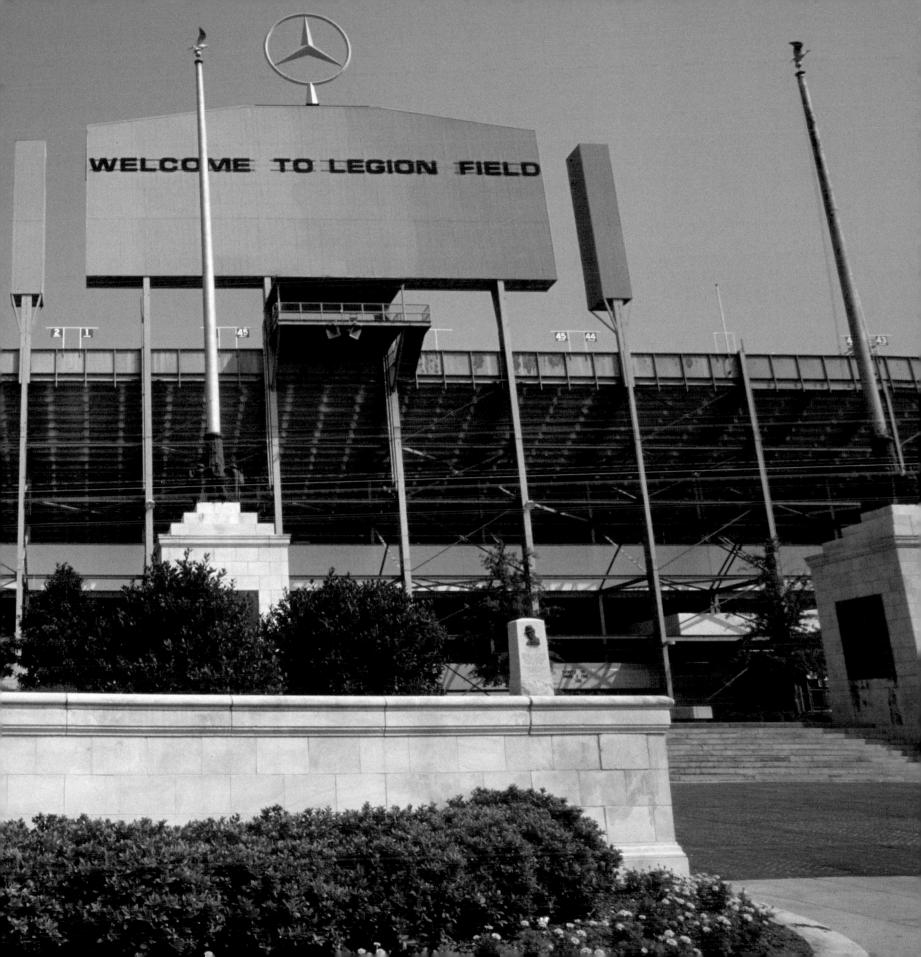

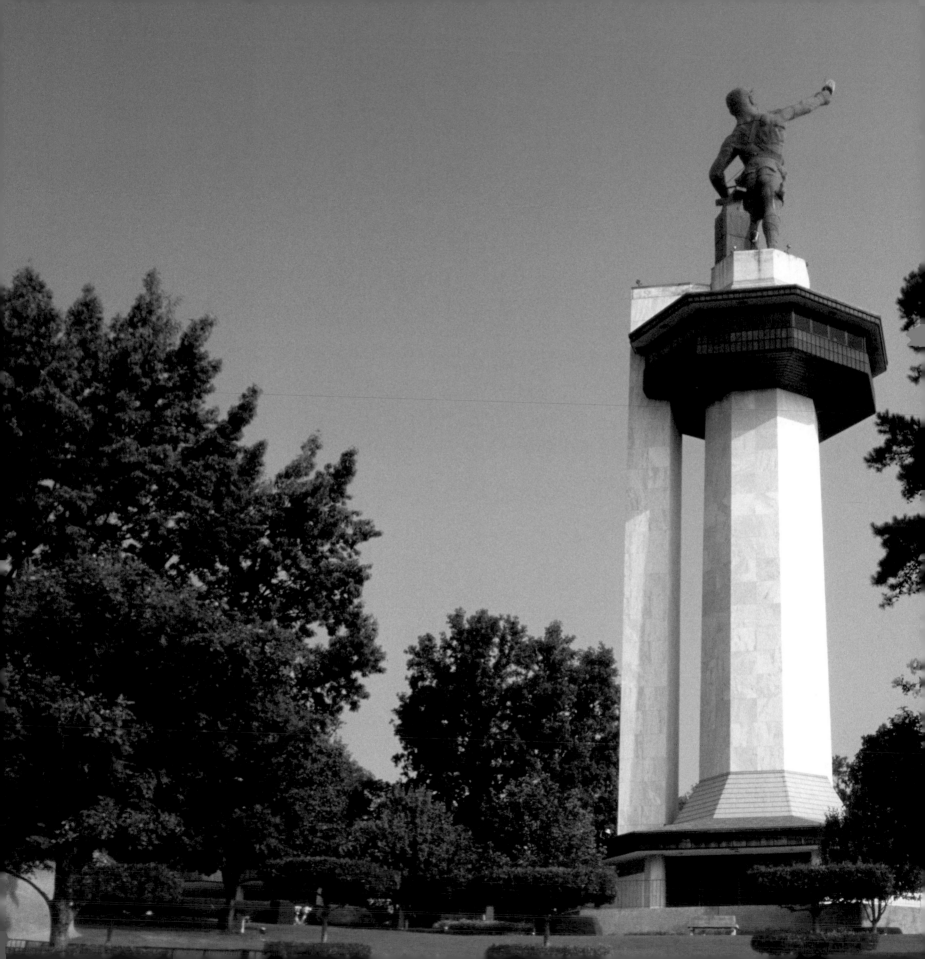

Standing atop a huge column in Birmingham's Vulcan Park, this rendering of the Roman god of fire is the largest cast iron statue in the world. Created for the World's Fair in Missouri in 1904, this 56-foot-tall statue of *Vulcan* is the second tallest statue in the United States, after the Statue of Liberty. Weighing in at well over 100,000 pounds, it is the biggest statue ever made in America.

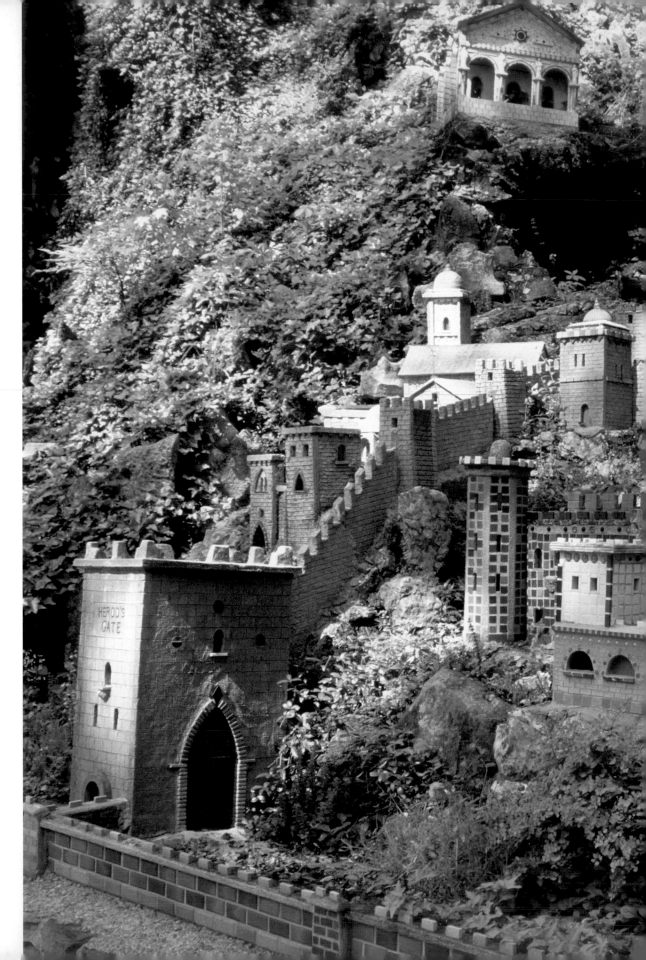

Some of the world's most important and beautiful sites are rendered in breathtaking miniature here at the Ave Maria Grotto in Cullman. Built by Brother Joseph Zoetti on the grounds of Alabama's only Benedictine abbey, the grotto's 125 delicate, intricate models replicate a vast array of cathedrals, temples, and historical structures — from the Tower of Babel and the Colosseum in Rome to the Leaning Tower of Pisa and the Statue of Liberty.

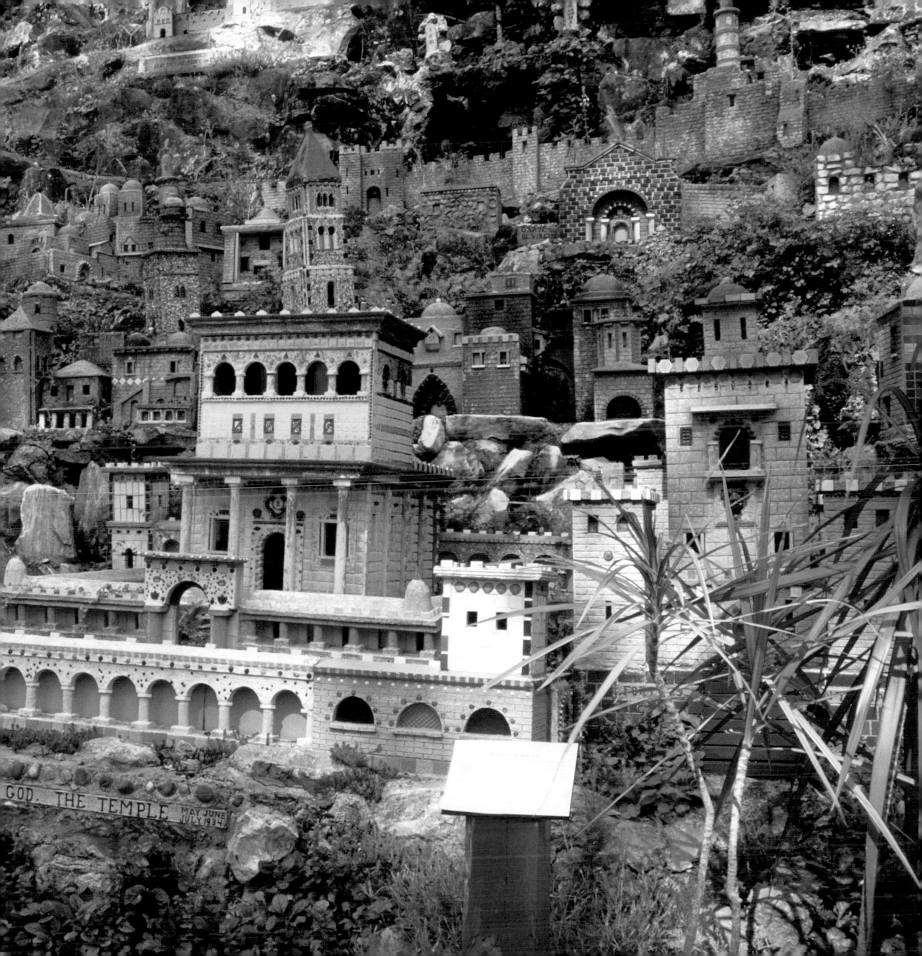

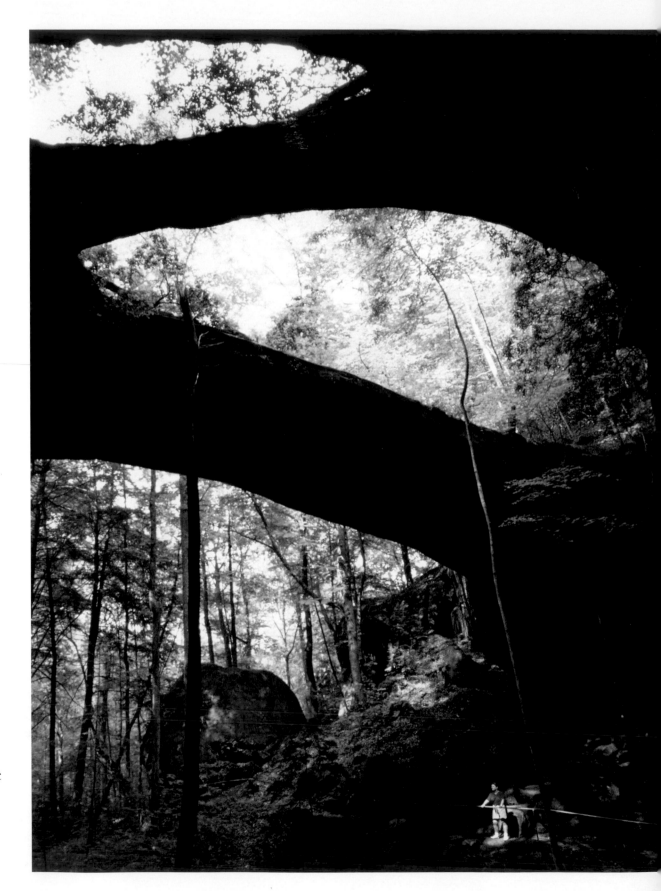

Formed over 200 million years ago, this sandstone and iron ore bridge is the longest natural bridge east of the Rocky Mountains. Located within the tiny town of Natural Bridge, the structure is 148 feet long and 60 feet high.

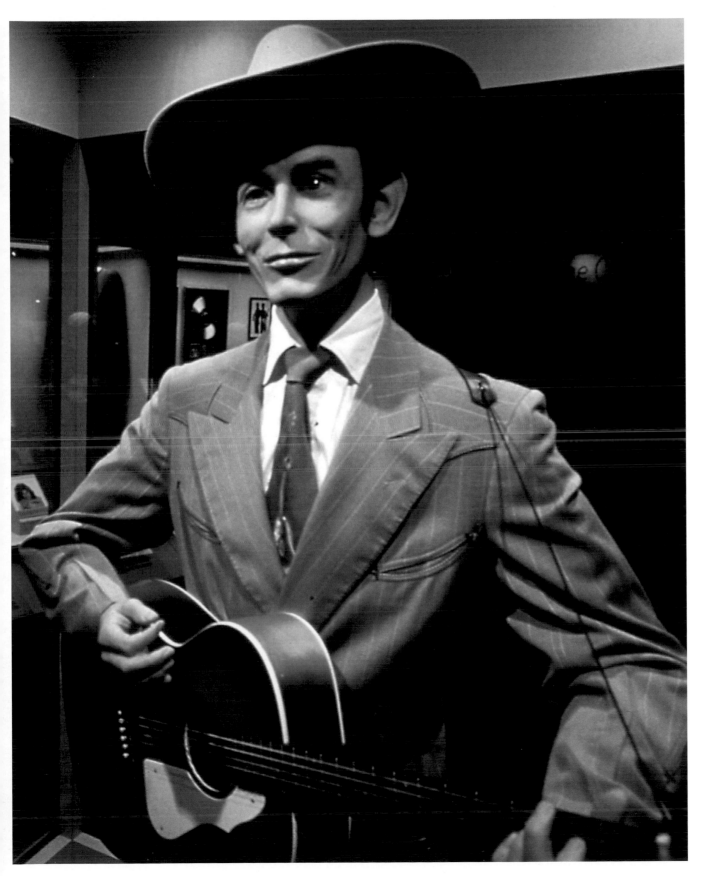

Iconic musician Hank Williams strums his guitar for all eternity here at the Alabama Music Hall of Fame in Tuscumbia, which honors the impressive number of musicians hailing from the state through a Walk of Fame and an exhibit hall. Also among the roster of famous Alabamians inducted into the state agency are Dinah Washington, Lionel Richie, and Emmylou Harris.

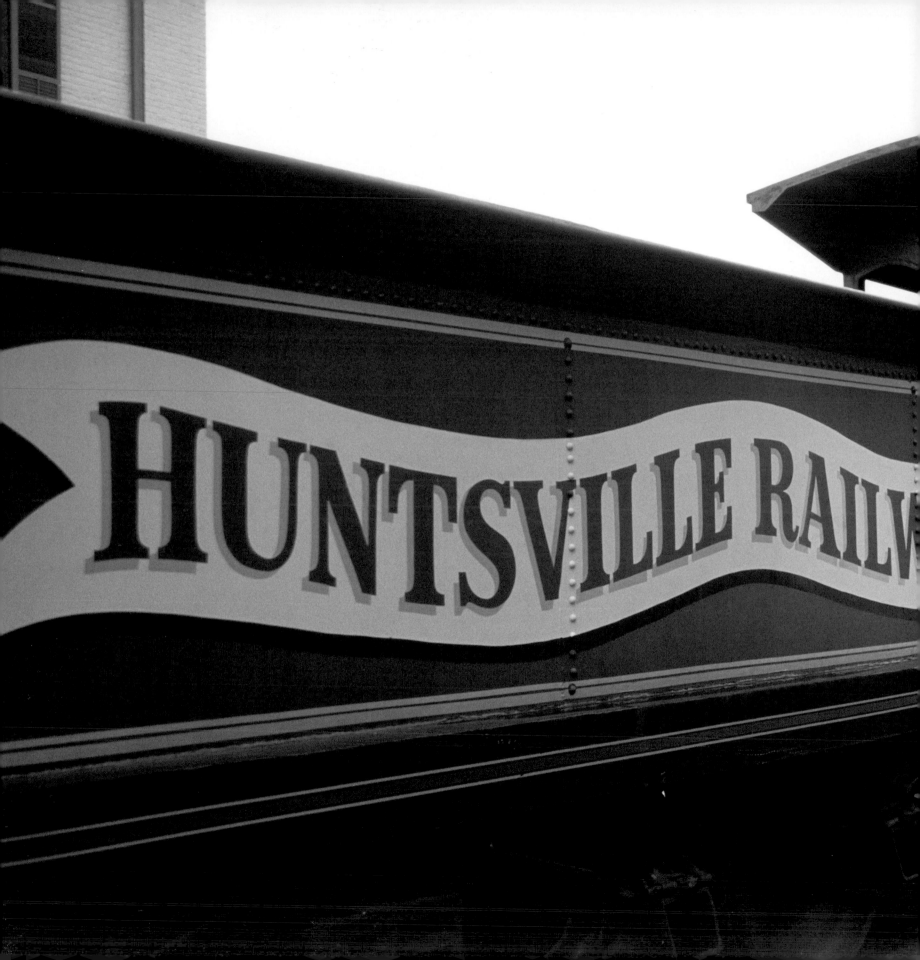

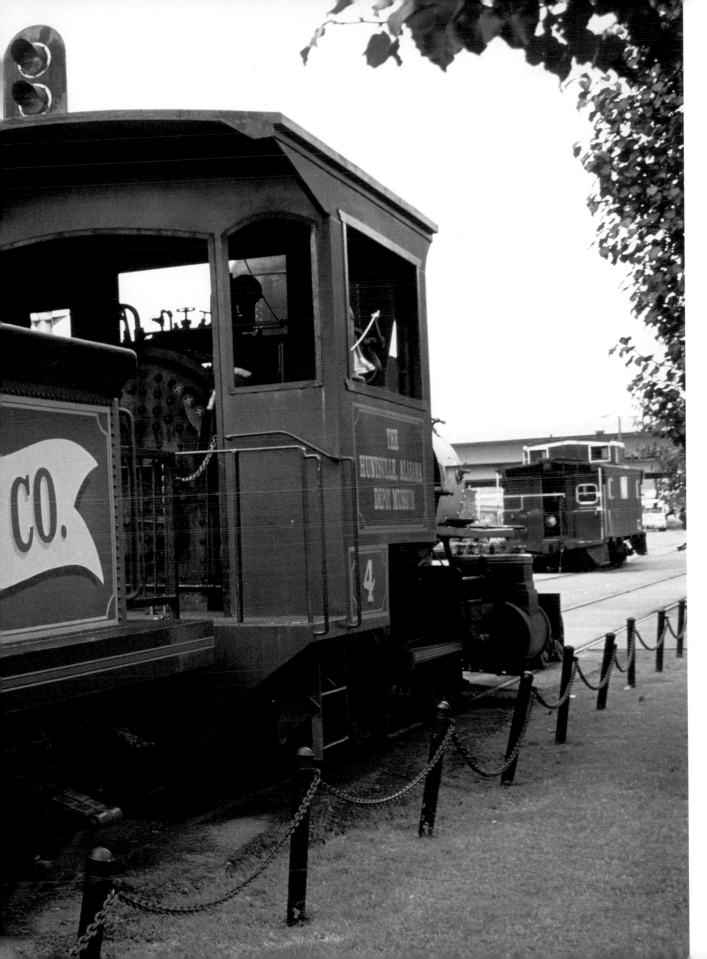

Highlighting railroad history and its effect on the South, the North Alabama Railroad Museum in Chase runs three historic locomotives from its restored depot. Once the smallest union railway station in America, meaning it once served two separate railroad tracks, the Chase depot was built in 1908 by the Chase family.

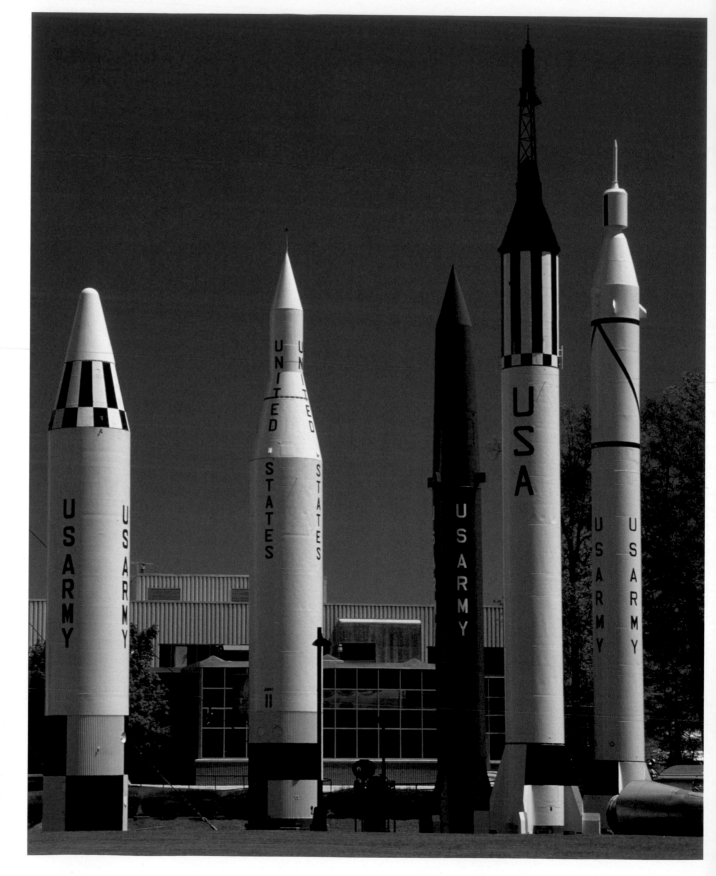

From rockets to simulators, the Space and Rocket Center in Huntsville, Alabama, houses over 1,500 pieces of space hardware. Space-themed exhibits chart the Apollo program, and visitors can simulate space travel through rides like the G-Force Accelerator.

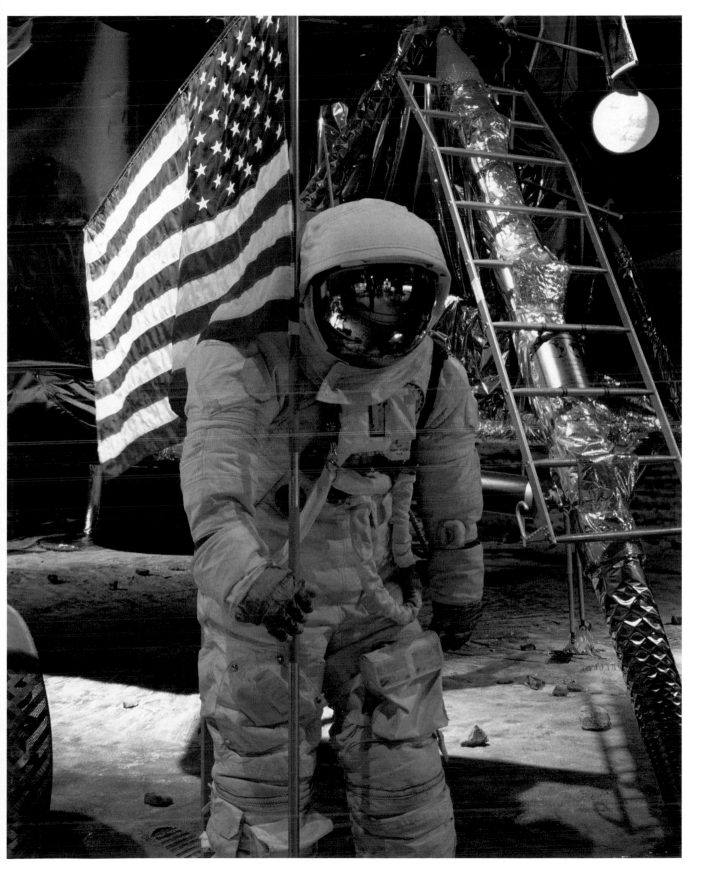

The suit of astronaut Gus Grissom — the first American to visit space twice — is on display at the Space and Rocket Center in Huntsville among a collection of NASA suits worn by astronauts on the Apollo missions. As one of NASA's original Seven Mercury Astronauts, Grissom was part of the Apollo program from its beginning until his death during a training exercise for Apollo 1.

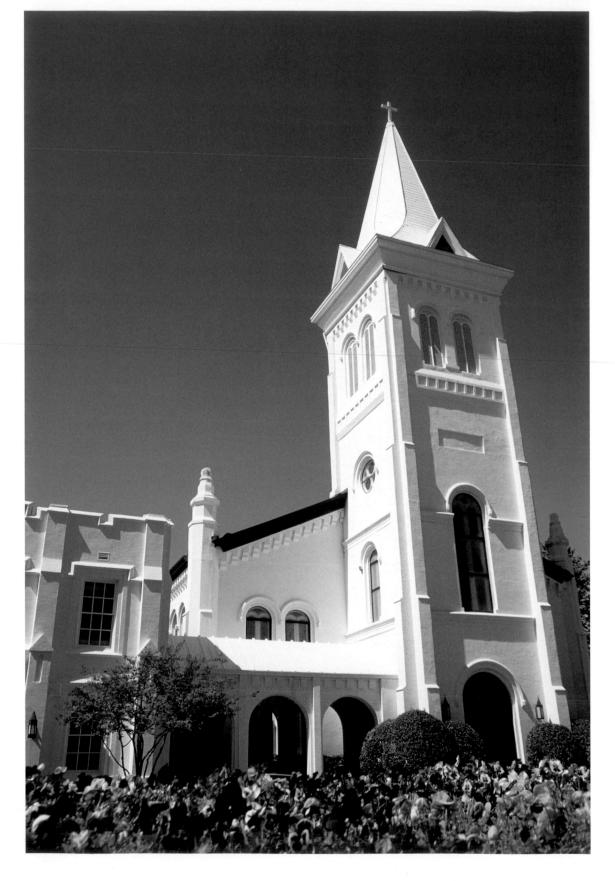

One of Alabama's first pieces of legislation after joining the union as the 22nd state in 1819 encouraged religious organizations to buy real estate. The first Methodist church in Huntsville was completed two years later, and as the congregation grew it was soon deemed inadequate in size. A larger church was built here on the site of the First United Methodist Church, but burned down during the Civil War. The cornerstone for this graceful building was laid in 1867, and the church was dedicated in 1874.

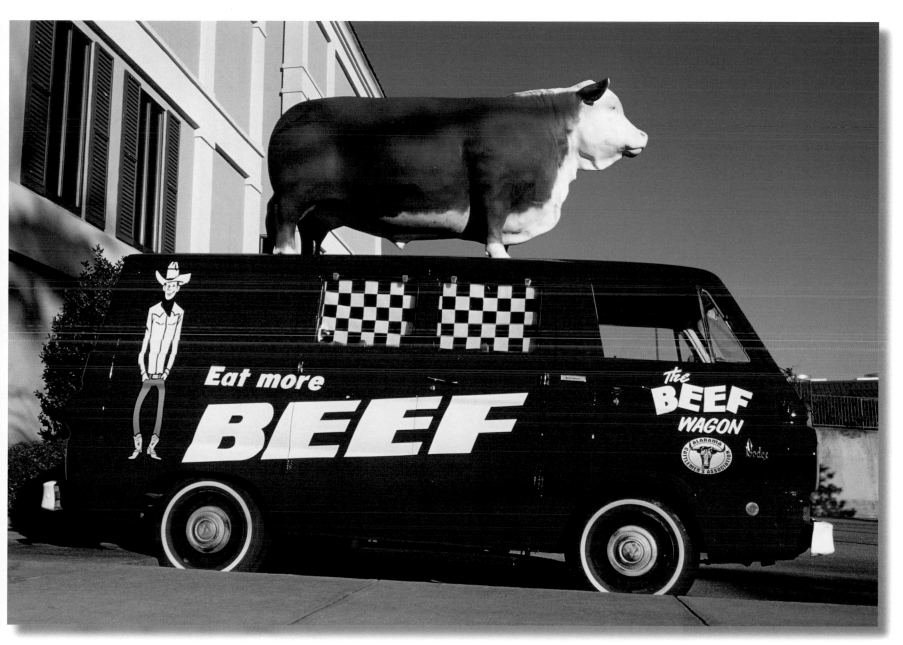

Alabama's mild climate and year-round precipitation make it an ideal place to raise cattle and produce fodder for foraging. With a mandate to promote beef consumption and production, the thousands of members of the non-profit Alabama Beef Cattlemen's Association serve as the state's beef council, supporting and expanding the billion-dollar industry.

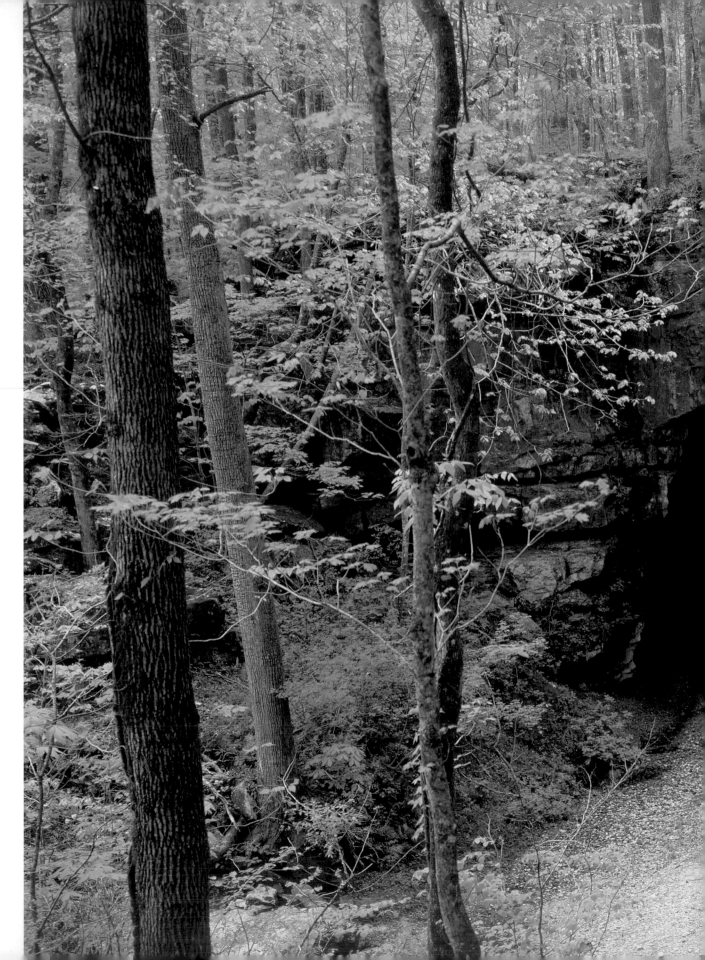

The archeological site here at Russell Cave National Monument near the town of Bridgeport is rife with hints about the lives of the prehistoric people who once called this area home. The third-longest mapped cave in Alabama, Russell Cave offers the Southeast's most comprehensive evidence about the communities who lived here more than 10,000 years ago.

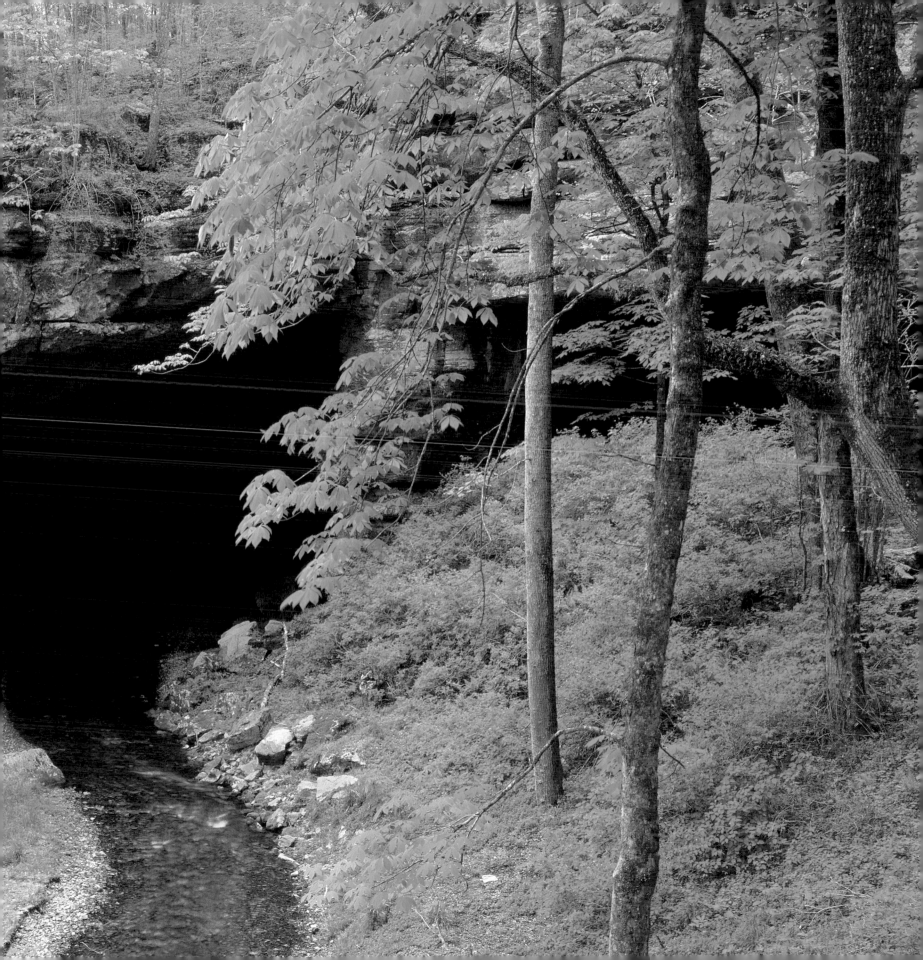

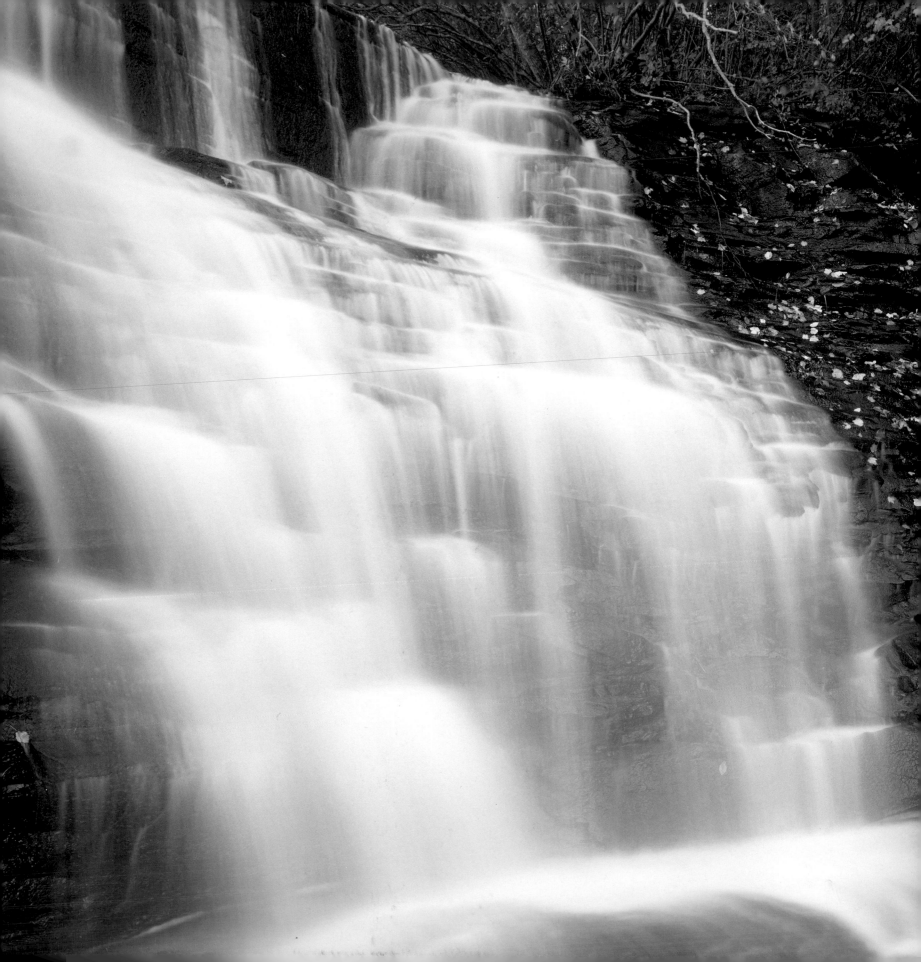

Located in DeSoto Falls State Park, the 104-foot-long DeSoto Falls are some of the longest in Alabama. Named for Hernando deSoto, the Spanish conquistador whose expedition through the Southeastern and Midwestern United States in 1539 was the most extensive of the 15th and 16th centuries, the DeSoto Falls have carved natural caves through years of erosion.

Photo Credits